Vassé's 'Bambinelli'

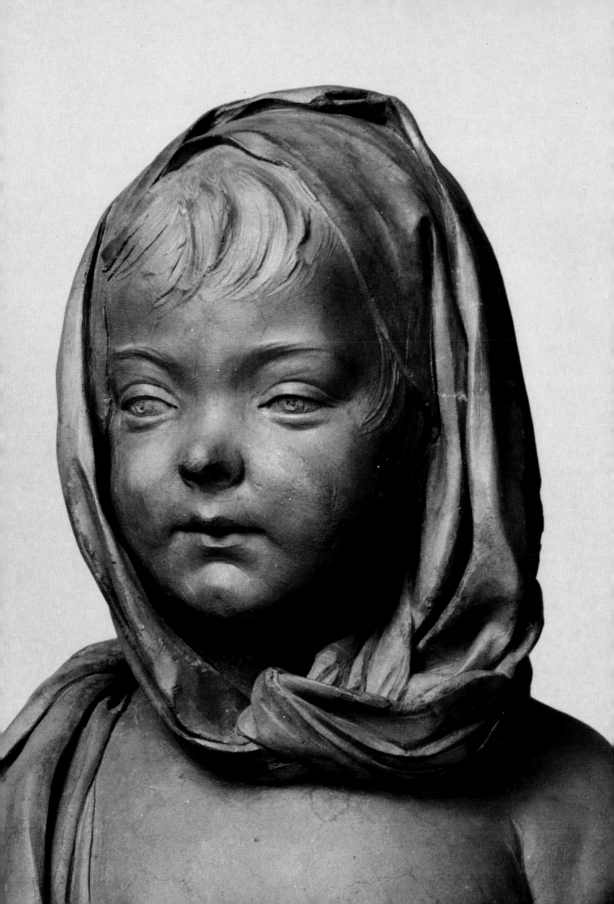

Vassé's 'Bambinelli'

The Child Portraits of an 18th-Century French Sculptor

Bernard Black

THE ATHLONE PRESS

London & Atlantic Highlands, NJ

First published 1994 by
THE ATHLONE PRESS
1 Park Drive, London NW11 7SG
and 165 First Avenue,
Atlantic Highlands, NJ 07716

British Library Cataloguing in Publication Data
*A catalogue record for this book is available
from the British Library*

ISBN 0 485 11444 5

Library of Congress Cataloging-in-Publication Data applied for

Photographic Acknowledgements

Figs. 1, 2 (*detail*), 21, 23, 26, 27: Cliché Réunion des Musées Nationaux,
Paris. Figs. 2, 3, 4: Musée des Beaux-Arts de Caen; Martine Seyve,
photographer. Figs. 5, 6, 28: John Hammond, photographer. Figs. 7, 8:
Courtesy, Wildenstein & Co., New York City. Figs. 9, 17: H. E.
Huntington Library and Art Gallery, San Marino, California. Fig. 10:
Courtesy, Parke Bernet Galleries Inc., New York City. Fig. 11: Musée
des Beaux-Arts de Lyon; Studio Basset, photographer. Figs. 15, 19, 29,
30, 31: Bibliothèque Nationale, Paris. Fig. 16: Courtesy, Sotheby's,
London. Fig. 18: Courtesy, the Trustees, Victoria & Albert Museum,
London. Fig. 20: Mike Fear, photographer. Figs. 22, 24: With the
co-operation of the Library, Wallace Collection, London. Fig. 25:
Metropolitan Museum of Art, New York City. Figs. 12, 14: Author.

Frontispiece Detail of Figure 6.

Produced for the publishers by
John Taylor Book Ventures
Hatfield, Herts

Typeset by
Nene Phototypesetters Ltd, Northampton

Printed and bound in Great Britain by
BAS Printers Ltd, Over Wallop, Hampshire

Contents

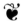

Figure 1 Etienne Aubry, *Louis-Claude Vassé* (1717-1772), oil. Musée de Versailles.
The sculptor is seen modelling a head of Minerva, a study for the large marble statue,
Minerve appuyée sur son Bouclier, which he exhibited at the Salon of 1767.

Introduction
and Acknowledgements

IN any survey of the sculptors of eighteenth-century France and, more particularly, the reign of Louis XV, the name of Louis-Claude Vassé appears prominently. He was a distinguished *sculpteur du Roi* and Professor at the Academy, as well as a regular exhibitor of a broad range of works at the yearly Salons, from 1748 to 1771. However, he was not, like Pigalle or Bouchardon or Lemoyne, for example, in that first rank of sculptors of the period whose names spring instantly to mind and he remains a shadowy figure, remembered as much for his opprobrious behaviour to his fellow Academicians as for the value of his *oeuvre*.

In 1986, the Musée du Louvre acquired, by donation, a remarkable carved marble statue of a *Seated Cupid, gathering doves for the chariot of Venus* by Louis-Claude Vassé. It was published subsequently by Jean-René Gaborit, Conservateur en chef of the Department of Sculpture, who noted the splendid provenance of this figure (it was originally commissioned by the celebrated collector and connoisseur, La Live de Jully, and later

acquired by Madame Du Barry and, in time, by the Empress Josephine, for Malmaison) in a well-documented article and in catalogue entries.[1] Other than this brief flurry, however, the literature on Louis-Claude Vassé is almost negligible and comprises Lami's biographical entry and catalogue in the *Dictionnaire*, Louis Réau's useful biography, written for the *Gazette des Beaux-Arts* in 1930 and one or two articles on individual sculptures, particularly François Souchal's informed study of a life-size marble fountain figure, *The Nymph of Dampierre*, which was acquired by the Metropolitan Museum of Art in 1971.

More recently, Michael Levey revised and expanded his important survey of French eighteenth-century sculpture, originally written for the Pelican History of Art twenty years ago. In it, he cites Louis-Claude Vassé's importance but it is evident that he does not admire the sculptor's surviving works and his appraisal of Vassé remains cursory and even erroneous.[2] It is true that Vassé's larger monuments and figures, while displaying an undeniable technical virtuosity, fail to stir the emotions. They are early prototypes of the return to classicism, rather mechanical in their invention, and they strike today's viewer as remote and cold.

Yet, for Louis-Claude Vassé's contemporaries, his sculptures could be moving to extremes: his *Woman weeping over an urn which she covers with her robe*, for instance, commissioned as a funerary monument for the recently-demised Princess Galitzine, was extravagantly eulogised: '... *never has grief been so well portrayed ... This figure is a miracle of expression ... on seeing it one cannot refrain from some emotion and be tempted to mingle one's own tears with those that one sees being shed.*'[3] and it was widely agreed that no sculptor more successfully carved a *pleureuse* so profoundly embodying despair and the subject became a Vassé speciality, recurring throughout his *oeuvre*.

In the late nineteenth and early twentieth century, it was Louis-Claude Vassé's sculpted portraits of young children which delighted *amateurs* and art historians and the present study is the first to consider these in depth, greatly augmenting (and correcting) the few paragraphs of Louis Réau's 1930 article which discussed some of them and which remains the only general appraisal of them to this date. In France, in the early decades of this century, Vassé's carvings of children were certainly well-known and valued, examples of them having belonged to famous collectors of the day, including Jacques Doucet and David-Weill, and appeared in major auction-sale catalogues of such collections. In a notable instance, in Paris in 1899, one of the sculptor's small marble busts of a child, belonging to the Duc de Talleyrand, was offered in a one-lot catalogue of its own (Figs.29–31), a distinction reserved today for, say, a major Bernini carving. It brought Fr.20,700 when, for comparison, in the same year, Houdon's life-size marble bust of *Molière*, also from the Duc de Talleyrand, had brought Fr.49,000 and, in the Mühlbacher sale, the same sculptor's finely-carved groups, *Le baiser donné* and *Le baiser rendu*, brought Fr.61,000 for the pair. It was, undoubtedly, such an evaluation which encouraged the shrewd, early twentieth-century *pasticheur*, Fernand Cian, to inscribe Vassé's name on some of his slick terracotta busts of 'eighteenth-century' children, examples of which Professor Souchal has generously brought to my attention. Surely, no better evidence of their desirability at that period can be imagined.

Inevitably, the Vassé child portraits were noted and discussed in the more numerous and ample art-journal pages of the period by authoritative writers in the field of French sculpture, including Paul Vitry and Carle Dreyfus, both Conservateurs at the Musée du Louvre. The fact that no-one had been able to propose an

identity for any of the children, to give them a name and a rationale, beyond the sculptor's masterly portrayal of their spirited infancy, was regretted by both Vitry and Réau[4] and the busts have remained a disassociated group, barely-known and undocumented, so that, even now, in major collections, a boy is published as a girl, while a brother and sister stand, side by side, unrecognised. A combination of intuition and research has, however, enabled me to propose identities for several of the subjects and, more beguilingly, bring them into Louis-Claude Vassé's own family.

Vassé's 'Bambinelli' was written originally as an article and, in that form, it was read by both François Souchal and Françoise de la Moureyre at the *Gazette des Beaux-Arts*. I am most grateful to these two eminent historians in the field for the warmth of their response to my observations and for an ongoing interest in their publication, particularly Professor Souchal, who has himself studied Vassé's *oeuvre* for many years. It has encouraged me to augment my original article with a section on Louis-Claude Vassé's life and abrasive personality and another which sets his child portraits in the context of similar works by some of his sculptor contemporaries. To Hugues Nadeau, I owe much: for his keen and critical eye, his diplomatic negotiations for special photography with the French museums and his unwavering enthusiasm for the project over a long period. Without his involvement, this study would be diminished in value.

Here, then, rescued from anonymity and reunited, are Louis-Claude Vassé's *'bambinelli'* – carvings *'d'une rare séduction'*, as Vitry described one of them[5] and, hopefully, another step in the reassessment of an important sculptor.

Bernard Black

Monte Carlo, January 1991 – April 1993

NOTES TO INTRODUCTION (numbers 1–5)

1 Gaborit, 1987, 1988, 1992.

2 Levey, 1972, pp.80–81, remarks that the young Vassé went to Rome as a pensioner in 1740, the same year as Saly, 'but taking second place'. In fact, Saly won the Prix de Rome in 1738 and Vassé won the Prix de Rome in 1739. Both had to wait until 9 March 1740 to receive their *brevet de pensionnaire* when, presumably, places became available (Guiffrey, 1879, pp.387,391). Vassé arrived in Rome shortly after and Saly some months later. Levey also asserts that Vassé spent more time on intriguing than he did on executing works of art but the abundance of the sculptor's recorded works belies this and Lami's catalogue of them, including sculptures of all genres which Vassé exhibited at the Salons over twenty-three years, covers several pages. Regrettably, these statements are unchanged in the revised edition of 1993.

3 '… jamais la douleur n'a été si bien rendue … Cette figure est d'un miracle d'expression, en la voyant on ne peut se défendre de quelque attendrissement, et l'on est tenté de mêler des larmes, aux larmes qu'on lui voir répandre.' *Lettre sur les Arts écrite à Monsieur d'Yfs … de Caen par M. du P …, Académicien associé.* Paris, 25 septembre 1763, in: George Duplessis, *Catalogue de la Collection des Pièces sur les Beaux-Arts* (Collection Deloynes) Paris, 1881, vol.XLVIII, no.1289, pp.57–58.

4 'Quant à l'identité du modèle,' *(L'enfant au fichu)* 'la tradition ne nous l'indiquant pas, il est, bien entendu, inutile d'espérer la retrouver avec aussi peu d'indications pour nous guider.' *('As to the identity of the model, tradition not telling us, it is, obviously, useless to hope to discover it with so little to go on.')* Vitry, 1903, p.11. 'Mais il n'a malheureusement pas été possible jusqu'a présent de désigner les modèles de ces petits chefs-d'oeuvre …'. *(But unfortunately it has not been possible up to now to name the models for these small masterpieces …'.)* Réau, 1930, p.54.

5 Vitry (op. cit., note 4) was, again, discussing the Doucet marble.

1

On Louis-Claude Vassé: Art and Antipathy

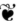

IN late seventeenth- and eighteenth-century France, many of the most gifted painters, sculptors and architects were members of multi-generation dynasties of artists, and their family trees, sometimes knitted together by intermarriage, branch and descend, testifying to an extraordinary flowering of consanguineous talents.[6] Louis-Claude Vassé was born into such a family although the line of inherited vocation ended with him. His grandfather, Antoine Vassé (or Vassez, as it was originally spelled) was born about 1655 in Amiens in Picardy but left at an early age to work as a sculptor's apprentice in Paris. He was later employed, briefly, by Jean Dubois (1625–1694) in Dijon and there was also a short period in Lyon before he arrived in Toulon where an ambitious programme of ship-building for the fleet of Louis XIV was offering ample opportunities of employment for sculptors and woodcarvers from all over France. Evidently, he arrived towards the end of the great Pierre Puget's term as the director of artistic production at the Arsenal (1668–1678)[7] and Antoine Vassé appears to have worked there steadily, as '*entrepreneur de travaux*

de sculpture pour la marine', until almost the end of the century.[8] Like many of his fellow artists, he left Toulon when a decline in financial support for the shipyards reduced their activities. The rest of his life is obscure and even the date of Antoine's death, certainly before 1700, is not known. He had married in Toulon in 1680 and his first son, François-Antoine, who was the only child to follow the father's profession, was born there in 1681.

François-Antoine gave a far greater lustre to the name of Vassé than did his father, with whom he first studied at the Arsenal of Toulon, where the influence and the inspiration of Puget were still pervasive, before going to Paris in 1707 to continue his studies at the Académie.[9] He was to become one of the outstanding decorator-sculptors of his time, recognised and employed from an early age as a designer and creator of ornaments by Robert De Cotte (1656–1735), the important and influential architect of the late seventeenth and early eighteenth century. As he matured, he also maintained the family association with ship decoration and was named *Dessinateur-général de la Marine* in 1715. He was paid 1000 *livres* a year by the King for designs and models for the decoration of vessels for the Royal fleet and his drawings of ship decoration are so fine that, although not of the same generation, they have sometimes been wrongly attributed to Pierre Puget. The relationship with De Cotte had by now developed into that of collaborator and the commissions became more prestigious - for example, the decoration of the Salon d'Hercule in the Palace of Versailles and of the choir and the Lady Chapel of Notre-Dame. His masterpiece is probably the theatrical, rococo interior of the Galerie Dorée in the Hôtel de Toulouse in Paris, with its profusion of wood carving and plaster or stucco sculptures (1717–1719), handsomely maintained by the Banque de France which has long occupied the house.[10] He was also a capable

sculptor in marble and his life-size figure of *Glory*, crowning the King, remains *in situ* in the chapel of Versailles, as does a *Virgin and Child*, dated 1722, in Notre-Dame. His career was curtailed by illness in 1731 and he died in 1736.[11]

François-Antoine had married in 1713 and had several children but, as in the previous generation, it was the oldest son alone, Louis-Claude, who inherited the family talent. There is a long-standing misconception about his year of birth, which has been given as 1716 in the literature, including Lami and Réau,[12] almost without exception. The most recent Musée du Louvre publications perpetuate this erroneous year. Nevertheless, the Archives de la Seine record his birth-date as 8 May 1717 and the year is confirmed by the death certificate of his father, François-Antoine Vassé, in the parish of Saint-Germain-l'Auxerrois on 1 January 1736, in which the age of his oldest son, 'Claude-Louis', is given as 18½.[13]

As the gifted son of a *sculpteur du Roi*, Louis-Claude's training had a smooth and conventional progression. He became the most promising of Edmé Bouchardon's pupils and many of his later sculptures demonstrate the influence of his *maître*. In 1739, he won the first prize for sculpture with a carved relief of *Jezebel mangée par les chiens* and, consequently, the privilege of being a *pensionnaire* of the King at the Académie de France in Rome. His *brevet d'élève* was signed on 9 March 1740.[14]

While he was in Rome, during the directorate of Jean-François De Troy, the young sculptor acquired a reputation for aggressiveness and impatience. He was unhappy with making copies after the antique, the traditional occupation of the *pensionnaires*, and when De Troy acquired a group of fine plaster casts, including one of Bernini's bust of Louis XIV, Vassé hoped to carve a marble copy of it. The bust was never achieved although a piece of

Carrara marble had been ordered for it and De Troy wrote to
Paris in 1741 that it could serve for another sculpture.[15] Vassé also
wanted to sculpt an original work but this found no support from
Philibert Orry, the current *directeur-général des Finances*, who
kept a firm hand on the Rome expenditures, even though the
sympathetic De Troy had written to Orry that Louis-Claude was
now well able to achieve *'fine things'*.[16]

Vassé returned to Paris in 1745, shortly after his term as
pensionnaire was completed. He was *agréé* to the Académie royale
three years later, becoming full Academician on 31 March 1751,
for which his *morceau de réception* was a *Berger endormi* (Louvre)
which was exhibited at the Salon and considered by some to be
over-indebted to Bouchardon's powerful copy of the sleeping
Barberini Faun. He became *adjoint à professeur* at the Académie
in 1758 and full Professor in 1761 and his career was moving
foward in a satisfactory and traditional manner but he had
attracted the attention of the Comte de Caylus who found, in
Vassé, his most promising protégé. Prestigious commissions
certainly followed but they were at the expense of amicable
relations with his fellow Academicians.

Anne-Claude-Philippe de Tubières, Comte de Caylus (1692–
1765), was a wealthy *amateur* of varied talents – an archeologist
and an obsessive antiquarian, an active member of the Académie
de Peinture et de Sculpture, to which he read eulogies of departed
confrères, an admirable engraver and a man of letters. He was,
above all, influential and an intriguer. There were several such
critics and tastemakers at that time, deeply involved in the artistic
milieu and seeking to impose their aesthetic on the working
artists, even to proposing the subjects for them to paint and
sculpt[17] but none was more powerful and manipulative than
Caylus. Of all the *'donors of ideas'*, as Charles-Nicolas Cochin

fils, the engraver and memoirist, ironically dubbed them,[18] none equalled Caylus in the domination of the painters and sculptors they chose to influence. Caylus' contemporaries called him tyrannical, the Baron Grimm describing him as *'the protector of the arts and the scourge of the artists'*.[19] Cochin acknowledged Caylus' intellect but gave the most cogent description of his personality: *'… he was vindictive to excess, to a point where he never forgave anyone who, no matter how it happened, whether by design or not, went against his will in something. Furthermore, he was excessively partial, so that, from the moment that he had espoused the talents of an artist he became insensitive to the merit of the others, everything had to be done in the style of the favourite, anyone who moved away from it became, for that reason alone, bad. Even worse: if any other artist of repute opposed the one he liked, he became the enemy'*.[20] When Caylus died, Diderot was caustic: after regretting the loss of several fine artists during the year, in his review to Grimm of the Salon of 1765, he added: *'To compensate, death has delivered us from the most cruel of "amateurs", the Comte de Caylus'*.[21]

If Caylus is dwelt on at length here, it is because all contemporary reports leave no doubt that Vassé's career was conducted by the Comte for his own purposes. The effect of his influence on Louis-Claude Vassé and of his machinations to make the sculptor the most successful of his generation cannot be overstated. With this powerful support, Vassé was to obtain advantageous commissions, often at the expense of his *confrères*, whose claims to the work were overturned. Unfortunately, Louis-Claude's consuming ambition, allied to a lamentable lack of scruples, made him not at all averse to this misuse of power to best his rivals and he became totally subservient to Caylus. It led him into a series of bitter contretemps with his fellow sculptors, three of which are documented.

Since 1736, Bouchardon had been *dessinateur* at the Académie des Inscriptions et des Belles-Lettres, a prestigious post which carried with it responsibility for the design of *jetons* and the numerous commemorative medals that were issued to honour the King, as well as an annual salary of 1000 *livres*. In 1752, now in ill health, he was ready to resign and it would have been the normal procedure for him to name Vassé to succeed. However, Bouchardon, although still on good terms with Caylus, disapproved of the way Vassé's career was progressing. There was also a personal affront in that, while his former pupil's style owed much to and flattered Bouchardon, Vassé himself had acknowledged, while still in Rome, that he had disdained the precepts of application and discipline advocated by his *maître*.[22] Bouchardon was most reluctant to advance Louis-Claude's name but Caylus was determined that the post should go to Vassé and recruited a good friend of his and Bouchardon's, Pierre-Jean Mariette, to assist him to achieve his purpose. Mariette, a widely-respected collector, art historian and writer, later recalled: *'I had had all the trouble in the world to influence Bouchardon to agree ...'*,[23] confirming the ability that the more persistent *amateurs* had to nudge the art establishment into a preferred direction.

A few years later, a more blatant intrigue concerned the redecoration of the chancel of the Church of Saint-Germain-l'Auxerrois, the parish church of the Louvre. This illustrious commission had been awarded to the young and comparatively unknown Michel-Ange Slodtz, who worked diligently for several years on designs and a model of the undertaking. Unfortunately for Slodtz, one of Mariette's daughters had married a wealthy merchant of Saint-Germain-l'Auxerrois and the burghers of that parish held her father in high esteem. Caylus again prevailed on his friend to influence them to reject Slodtz' submitted designs

and pass the commission, instead, to Vassé's brother-in-law, Claude Bacarit, as architect for the project – with the added function of acting as a screen for the appropriation of the commission by Vassé, with the connivance of Caylus. Bacarit was given the commission but it was Vassé who, at the Salon of 1757, exhibited a model of his planned decoration, the *livret* adding a note that a larger model, showing the new embellishment of the sanctuary of the church, could be viewed at the sculptor's *atelier*.[24] For Michel-Ange Slodtz, Souchal comments, it was *'the most painful setback of his artistic career'*.[25] For Louis-Claude it must have been a doubly-satisfying prize: Saint-Germain-l'Auxerrois had become, in effect, the Vassé family church – his father had been buried there and he would be buried there too.

The most serious condemnation of Vassé's moral values, however, followed the affair of the monument to Louis XV, commissioned by the City of Paris for the Place Louis XV, now the Place de la Concorde. Again, Edmé Bouchardon was involved: he had been nominated in 1748 to submit his designs for the splendid statue – the mounted King, high on an elaborate pedestal – and had already achieved the figure of the King and much other work, when he fell fatally ill. Knowing he would never live to complete the monument, it became necessary to name a successor. Again, Louis-Claude Vassé, as his most accomplished pupil, would have been the traditional choice – just as, when Vassé himself died in 1772, before his funerary monument for King Stanislas was completed, his own best pupil, Félix Lecomte, completed it. In fact, Vassé was already involved in the Louis XV monument and had been occupied since 1759 in the execution of reduced bronze versions of the equestrian figure alone.[26] But Bouchardon was determined that Vassé would not be the sculptor to complete the elaborate pedestal, for which he had already

partly completed the models for four standing caryatides, representing Virtues, two large bas-reliefs of compositions apotheosising Louis XV and sundry decorative trophies, all needing to be completed and cast in bronze. Assisted by the ubiquitous Pierre-Jean Mariette, whose admiration for Pigalle was evidently stronger than his loyalty to Caylus, Bouchardon wrote a carefully-composed and persuasive letter on 24 June 1762, advancing, in the most glowing terms, the name of Pigalle for the task.[27]

One month later, Bouchardon was dead. As it happened, Pigalle was also ill at the time and Caylus had almost convinced the Paris authorities to name Vassé to complete the monument when Bouchardon's letter was produced and Pigalle was duly nominated. The furious Vassé determined to discredit Pigalle and, when the latter submitted his estimates for the completion of the work, Vassé claimed that he could achieve it for half the cost, bringing in Etienne-Maurice Falconet (who had his own animosity towards Pigalle) to support his accounts.[28] After the Paris *échevins* appealed to the Académie to adjudicate, Pigalle's figures were found to be an accurate estimate while Vassé's were baseless. Pigalle's friends complained loudly to the Académie, demanding justice, and its disgusted members threatened Vassé with expulsion unless he apologised publicly to Pigalle. Cochin wrote: '*The result of this hubbub is that a kind of reprimand has been noted in the records of the Académie, telling him to be a little more circumspect in the future. At first he was hardly visible but, before long, he was back at the Académie, taking a lofty tone as if one had never had anything to reproach him for*'.[29] If Vassé was able to shrug off this humiliation, however, '*there was to be no further reconciliation with his colleagues who, from that moment on, ceased to look favourably on him*'.[30]

Louis-Claude Vassé was undeniably talented, if not greatly

inventive, and, without doubt, would have had a successful, less notorious, career if Caylus had not intervened. Contemporary opinion placed him in the sculptor élite of the Louis XV period. The hierarchy, established as much by the consensus of *amateurs* and critics as by royal favour was, Souchal records: the four 'greats' – Bouchardon, Pigalle, Falconet and Michel-Ange Slodtz – and, just below, the Adam brothers and Jean-Baptiste Lemoyne (but only for his portraits), then Guillaume II Coustou and Louis-Claude Vassé, neither of whom achieved greatness. Considered of second order were Vinache, Allegrain and Paul-Ambroise Slodtz, while Saly eliminated himself by going to Denmark.[31] Olga Raggio has called Vassé 'one of the most important sculptors of his time',[32] yet he remains less known than many of his *confrères* due, one may suppose, to the scarcity of accessible sculptures by him to study, compounded by the lack of a major monograph. It is ironic that, when Réau wrote his long, monographic article on Louis-Claude in 1930, he entitled it *'Un sculpteur oublié du XVIIIe siècle'* and, almost half a century later, in Michèle Beaulieu's entry on the sculptor for the catalogue of the exhibition *Louis XV – Un moment de perfection de l'art français*, he still remained *'un oublié de la sculpture'*.[33] Yet, he was extremely prolific and, thanks to Caylus, his commissions were ambitious and major – funerary monuments, portrait busts – both retrospective and *ad vivum*, mythological statues and charming *cabinet* figures. His patrons included Catherine the Great, her minister General Betzki, Count Chouvalov, Frederick the Great, Madame de Pompadour and Madame Du Barry. However, much of the religious work has been destroyed, the commissions for Russia and Germany dispersed abroad, the *cabinet* pieces in public collections few in number. As has been mentioned, the exquisite *L'Amour assis sur le bord de la mer rassemblant les*

colombes du char de Venus, which Gaborit calls the sculptor's masterpiece, entered the Louvre in 1986, rejoining another marble seated figure by Louis-Claude, *La Comédie*, which had also been in Madame Du Barry's collection at Louveciennes.[34] The seated *L'Amour* is indeed the finest example of Vassé's *retour à l'antique* and testimony to his carving skill in its subtle treatment of the anatomy of a soft young body, its silky surface and in the interplay of form and space offered by the bent, seated figure. In New York's Metropolitan Museum, Vassé's terracotta figure of *Flore*, a variant of *La Comédie*, shows the sculptor's mastery in modelling clay with, in Olga Raggio's words, a classically disciplined talent[35] while James David Draper has observed how Vassé breathed fresh life into the myth of Flora.[36] These rare, fine examples of Louis-Claude's more intimate works can only engender regret that such collectors of the 'perfection' of the Louis XV period as Sir Richard Wallace and Henry Clay Frick failed, for whatever reason, to acquire similar works by Vassé.

Pierre-Jean Mariette wrote of Louis-Claude Vassé: '*He had the good fortune to be born with talents of which he could have made better use if, in the first years he turned to sculpture, he had applied himself with more zeal to the study of his art and had taken advantage of the advice Bouchardon gave him … One could say that he took his facility for working for granted. There was grace and delicacy in what he did, but on closer examination one did not find it sufficiently substantial.*'[37] and one may surmise to what extent Vassé's principal fault – the frigidity and emptiness found in many of his major carvings – can be attributed to the influence of Caylus and his obsession with antiquity. Remembering the young *pensionnaire* in Rome who would rather have copied Bernini than the antique, it could be suggested that his mature style, calculatedly subservient to his patron's taste, resulted in this recurring lack

of warmth and of immediacy in the more ambitious marbles. In Rome, De Troy had once been faced with the need to have finished an important statue of *Antinous*, after the antique, because of the untimely death of its sculptor. From Paris, Orry allowed him to choose between Saly and Vassé and De Troy wrote later: *'I have given the work to Saly. It isn't because both of them aren't ready to be a credit to themselves but I believe that (Saly) is less likely to let himself be carried away by the liveliness of his style and will follow the delicacy of this admirable antique to the last detail'.*[38] That Vassé bartered his soul for privilege and fortune seems clear, resulting in the abrasive relations with his fellow Academicians and casting dark shadows on his personal reputation.

Inevitably, the critics of the day were pinched between their distaste for Vassé the man and their admiration for many of his achievements. Diderot despised Louis-Claude and his remark, *'I do not like Vassé, he is a villain ...'* is often quoted in the literature. Less often is the remark completed *'... but let us remember the quotation "without bitterness or partiality", let us be fair and concede what he deserves without respecting the person'.*[39] For Diderot could be generous when Vassé's sculpture pleased him: at the Salon of 1763, for example, he was another of those visitors for whom the Princess Galitzine funerary monument proved emotive. Reviewing Vassé's entries, he wrote: *'This "Femme couchée sur un socle carré, pleurant sur une urne qu'elle couvre de sa draperie" is a fine thing. Girardon has not done better on the tomb of Cardinal de Richelieu. Her misery is profound; one is touched by looking at it. How saddened her face is! serenity will not soon return. The whole pose is simple and correct, the arms well-placed, the drapery beautiful, the upper part of her body bent with grace; nothing that offends, nothing awkward; it seems that, in her place,*

one would not take any other attitude ...'.[40] In 1765, the Baron Grimm described a visit to Vassé's studio: '*M. Vassé, one of the most skilful sculptors in our Académie is showing in his studio the model of an audience-chamber executed by order of the Empress of Russia ... The manner in which M. Vassé has decorated this interior has been judged of great beauty, he has known how to combine simplicity, nobility and richness ... M. Vassé has demonstrated that he is not only a sculptor but an architect and a man of taste'.*[41]

When Vassé died on 30 November 1772, he was still in his mid-fifties and did not lack commissions. In the Salon of the year before, he had exhibited figures and drawings for several important funerary monuments, including that of King Stanislas of Poland, for the City of Nancy, on which he was still working at his death. Two days after the sculptor died, Bachaumont wrote in his *Mémoires secrets*: '*The arts have suffered a considerable loss in the person of M. Vassé, professor of the Académie royale de peinture et de sculpture: one must regret it even more at the moment when he leaves a great monument unfinished, the models for which make one want to see its completion ...'.*[42] For Diderot, the conflict between art and antipathy, when the subject was Louis-Claude Vassé, remained with him to the end and he was both elegiac and censorious on the sculptor's passing: '*The Académie ... has also just had a palpable loss in the death of Claude-Louis Vassé ... Vassé died in the prime of life, following a malignant fever. He was a very distinguished artist and consequently is to be regretted, at a time when the dearth of skilful people becomes increasingly obvious*', he wrote to Grimm. '*He was the pupil of the celebrated Bouchardon, from whom he retained his purity and classicism in the very centre of the advance of that style in the French school. The late Comte de Caylus nurtured his*

beginnings. Vassé could draw very well, a quality very rare among his fellow sculptors, who indeed know how to model but who are, for the most part, fairly inept with a crayon in their hands. Vassé's moral character was not of as intact a reputation as his talents, he was not liked by his colleagues and he was considered deceitful and a troublemaker.'[43]

It was a very discerning assessment of Louis-Claude Vassé's life.

NOTES TO CHAPTER 1 (numbers 6–43)

6 Three notable exceptions were Jean-Baptiste Pigalle, Etienne-Maurice Falconet and Jean-Baptiste Houdon, all of whom came from simple artisan stock, Houdon *père* being the concierge of the Ecole des élèves protégés.

7 See: Klaus Herding, *Pierre Puget*, Berlin, 1970, pp.237–42 for a chronology of these years.

8 Ginoux, p.133.

9 The literature sometimes suggests that François-Antoine Vassé was a pupil of Pierre Puget (e.g. Ballot, p.30) but this is a misunderstanding. If it is true to say that François-Antoine studied with his father in Toulon 'in the close circle of Puget' (Souchal, 1987, p.402), this is not to suggest the personal involvement of the great sculptor. By 1681, when the young Vassé was born, Puget was spending much of his time in Marseilles and making frequent visits to Versailles. François-Antoine was but thirteen years old when Puget died in 1694. On more than one occasion, the error has jumped a generation, making his son, Louis-Claude Vassé, 'a pupil of Puget'. (Ref.: Montaiglon, p.270; Benezit, *Dictionnaire*, vol.8, Paris, 1959, p.482).

10 Souchal, 1984, pp.421–430.

11 See Souchal, 1984, pp.402–405, for the most detailed summary of the life of François-Antoine Vassé, to date.

12 The reference 'Réau', without a date, in this study, refers in all instances to his 1930 monographic article on Louis-Claude Vassé (see Bibliography). Although Réau's study contains many inaccuracies and lacunae, it remains the only broad appraisal of the sculptor.

13 Arch. Nat. (M.C.) et CXIII, liasse 344. Louis-Claude's death certificate is also misleading, stating that the sculptor died on 30 November 1772, 'aged about 54', which would make his year of birth 1718 (parish records of Saint-Germain-l'Auxerrois, quoted by Herluison, *Actes d'Etat Civil d'Artistes français*, Orléans, 1873, p.444). In fact, he was in his 55th year when he died. Montaiglon (p.270) and Guiffrey (p.154) are the only two writers I have found who have given Vassé's birth year correctly although Guiffrey then misinforms that '… *il mourut le 1er décembre 1772*', when the burial notice of that date states that he died in the afternoon of the previous day: '*decédé d'hier à 3h de relevée*'.

14 Guiffrey, p.391: '*CCXXXIII – Brevet d'élève à Rome pour l'élève Vassé,*

sculpteur, fils du sculpteur du Roi; premier prix de 1739. (9 mars 1740)'. See also: *Correspondance*, vol.IX, p.416.

15 *Correspondance*, vol.IX, p.461, De Troy to Orry, 5 May 1741: 'Le bloc de marbre que j'avois fait venir par le S^r *Slodtz* pour le buste de Louis XIV, que le S^r *Vasse* devoir faire d'après le *Bernin*, servira à quelqu'autre ouvrage.'

16 *Correspondance*, vol.X, p.21, De Troy to Orry, 7 September 1742: '... ayant deux sculpteurs icy, savoir les S^rs *Saly* et *Vasse*, en état de faire belles choses ...'.

17 Weinheinker, p.76. Caylus' published works included *Nouveau Sujets de Peinture et de Sculpture*, Paris, 1755, and *L'Histoire d'Hercule le Théban ... à laquelle on a jointe la Description des Tableaux qu'elle peut fournir*, Paris, 1758.

18 Weinheinker, p.76.

19 Grimm and Diderot, vol.IV, p.330, 15 September 1765: 'Protecteur des arts et le fléau d'artistes'.

20 Cochin, p.26: 'il étoit vindicatif à l'excès; qu'il ne pardonnoit jamais à ceux qui, en quelque manière que ce fût, à dessein ou non, avoient en quelque chose heurté ses volontés. D'ailleurs, il étoit excesssivement partial, dès qu'il avoit épousé les talents d'un artiste le mérite des autres ne lui étoit plus sensible, tout devoit être dans la manière de ce favorisé: ce qui s'éloignoit lui paroissoit, par cela seul, mauvais. Il faisoit plus: si quelque autre artiste de réputation l'opposoit avec celui qu'il affectionnoit, il en devenoit l'ennemi'.

21 Seznec and Adhemar, vol.II, p.60: 'Nous avons perdu cette année deux grands peintres et deux habiles sculpteurs, Carles Vanloo et Deshayes l'aîné, Bouchardon et Slotz. En revanche, la mort nous a délivrés du plus cruel des amateurs, le comte de Caylus.'

22 Roserot, p.152.

23 Mariette, p.41: '... J'eus toutes les peinnes du monde à determiner Bouchardon à consentir ...'.

24 Guiffrey, J.-J., *Collection des Livrets des anciennes expositions ...*, Jacques Laget, ed., Nogent-Le-Roi, 1990, vol.III, Salon of 1757, p.29, no.135.

25 Souchal, 1967, pp.677–679, discusses this intrigue against Michel-Ange Slodtz at some length.

26 Roserot, pp.128-9. The work was not completed until early 1764 and the 24 statuettes, 7 in bronze and 17 in plaster, were delivered to the King, to Mme de Pompadour and members of the nobility and to the Paris *échevins*

who had commissioned the monument. An unspecified number of plaster versions, however, were in the sculptor's studio at his death (ref.: App. II, p.94, lot 38). A bronze version is in the Louvre (Beaulieu, p.71, no.52, illustrated).

27 The text of this long letter is given by Cochin (p.173) and also by Roserot (p.119), the latter suggesting that Mariette also kept the bedridden Bouchardon apprised of Caylus' efforts to obtain the work for Vassé. See also: Dilke, pp.78–80, 89–90, for a more fanciful account of these intrigues.

28 Réau, 1922, p.66. Cochin, p.59, relating this, noted that Falconet, hypocritically ('un peu à la Jésuite'), covered himself by adding *'if the account that M. Vassé has given me is correct'* ('Si l'exposé que me fait M. Vassé est exact …'). Réau notes that Falconet was *'a little double-faced'* himself and Cochin thought that his involvement in the affair was more reprehensible than Vassé's (ibid).

29 Cochin, p.63: 'La fin de cette rumeur, c'est qu'il fut inscrit sur les registres de l'Académie une sorte de réprimande, où il lui étoit d'être plus circonspect à l'avenir. Il y parut d'abord sensible; mais à peu de temps de là il revint à l'Académie, et y prit le ton aussi haut que si l'on n'avoit jamais rien à lui reprocher'.

30 Mariette, p.40: 'et ne s'en reconcilia pas davantage avec ses confrères qui, de ce moment, cessèrent de le regarder de bon oeuil'.

31 Souchal, 1967, p.167.

32 Raggio, Introduction.

33 Beaulieu, p.92, no.90.

34 Gaborit, 1987, p.39.

35 Raggio, no.2.

36 Draper, p.13.

37 Mariette, p.41: 'Il étoit né avec heureux talents dont il auroit pu profiter davantage, si dans les premières années qu'il se donna à la sculpture il se fût appliqué avec plus de zèle à l'étude de son art et qu'il eût sû profiter des leçons que lui donnoit Bouchardon … On peut dire qu'il se fia trop à la facilité avec laquelle il opéroit. Il mettoit de la grace et de la légèreté dans son travail, mais quand on venoit à l'examiner on n'y trouvoit rien d'assez solide'.

38 *Correspondance*, vol.X, p.21, 4427, De Troy to Orry, 7 September 1742: 'Par le choix que vous me laissez du Sʳ *Saly* ou du Sʳ *Vassé* pour finir la figure de *Lantin*, je l'ay donné au Sʳ *Saly*. Ce n'est pas qu'ils soient tous deux en état de se faire honneur; mais je crois que celui ci se laissera moins

emporter à la vivacité de son gout et qu'il suivra avec la dernière exactitude la finesse de cet admirable antique.'

39 Seznec and Adhemar, vol.III, p.322. From his review of the Salon of 1767: 'Je n'aime pas Vassé, c'est un vilain mais rapellons nous notre épigraphe, *sine ira et studio*, soyons juste, et louons ce qui le mérite, sans acception de personne'. He was quoting from Tacitus (*Annals*,I,1).

40 Ibid, vol.I, p.247: 'Cette *Femme couchée sur un socle* ...est une belle chose. Girardon n'a pas mieux fait au tombeau du Cardinal de Richelieu. Sa douleur est profonde; on s'attendrit en la regardant. Que ce visage est attristé! la sérénité n'y reparaîtra de longtemps. Toute la position est simple et vraie, les bras bien placés, la draperie belle, la partie supérieure du corps penchée avec grâce; point de gêne, point de contorsion; il semble qu'à sa place on ne prendrait pas une autre attitude ...'.

41 Grimm and Diderot, vol.IV (1764–1765), pp.309–310: 'M. Vassé, un des plus habiles statuaires de notre Académie, vient d'exposer dans son atelier le modèle d'une salle d'audience faite par ordre de l'impératrice de Russie ... La manière dont M. Vassé a décoré cet intérieur a été jugée d'une grande beauté; il a su réunir la simplicité, la noblesse et la richesse ... M. Vassé a montré qu'il n'était pas seulement sculpteur mais architecte et homme de goût'.

42 Bachaumont, vol.VI (4 December 1772): 'Les arts viennent de faire une perte considérable en la personne du Sr Vassé ... on doit autant plus le regretter actuellement qu'il laisse imparfait un grand monument dont les modèles saisoient desirer la terminaison ...'.

43 Grimm and Diderot, vol.VIII (1772–1776), pp.111–112: 'L'Académie de Peinture et de Sculpture vient de faire aussi une perte très sensible par la mort de Claude-Louis Vassé (sic) ... mort dans la force de l'age, des suites d'une fièvre maligne. C'était un artiste très distingué et par consequent très regrettable, dans un temps ou la disette d'habile gens se fait de plus en plus sentir. Il était élève du célèbre Bouchardon, dont il avait conservé le goût pur et antique au milieu des progrès de la manière dans l'école française. Le feu comte de Caylus avait eu soin de son enfance. Vassé était très-bon dessinateur, qualité très-rare parmi les sculpteurs ses confrères qui savent bien modeler, mais qui sont la plupart assez ineptes avec le crayon à la main. Le caractère moral de Vassé n'était pas d'une réputation aussi intacte que ses talens, il n'était pas aimé dans son corps et il passait pour sournois et tracassier.'

2

Vassé's
'Bambinelli'

❦

AFTER a reading of the scanty literature on the life of Louis-Claude Vassé, one category of his work, rarely ignored, evokes a puzzlement: what explanation could there be for the intriguing contradiction between the attested unpleasantness of his character and the sensitivity of the widely-praised series of child portraits which many writers have cited as exemplifying his skill as a sculptor? As will be demonstrated here, Louis-Claude created several captivating images of childhood in marble and terracotta which were among his finest works, innovative in their freedom from the conventional formality of such portraits in the eighteenth century and spontaneous in their treatment. *'Vassé's greatest claim to glory is perhaps his really exquisite collection of children's busts'*, Louis Réau asserted, *'his "bambinelli", as he called them, which herald and at times equal the delightful child portraits of Houdon'.*[44] Luc Benoist added: *'... the liveliest to be found before Houdon and which constitute the best of his work ...'*[45] and Paul Vitry emphasised: *'... long before the celebrated faces of Houdon'.*[46]

Yet, even this perceptive appreciation of the significance of Vassé's portraits of children was based on a limited, often erroneous, knowledge of them: as Appendix I shows, some of the subjects exist in no more than one or two versions and these have only surfaced on rare occasions. Documentation is thin and often misleading, while several of the busts have effectively disappeared and are known today only from old art journals or auction catalogues; even the *livrets* of the Salons in which Louis-Claude Vassé exhibited three of the busts, lists each of them, baldly, as *'Une tête d'enfant'*, contributing little assistance.[47] Consequently, the present observations and the appended historical record of the body of Louis-Claude Vassé's child portraits known at this date, will clarify a little-known and confused category of his work and contribute significantly towards the eventual publication of a *catalogue raisonné*. As many sculptures as possible have been illustrated here or, if this proved infeasible, the appropriate Appendix entry refers to any illustration known to have been published.

The first documented portrait of a child by Vassé was executed in Rome, during his four-year term as a *pensionnaire* at the Académie de France. The Director of the Académie, from 1738 until 1751, was Jean-François De Troy, an historical painter and an able administrator, popular with the students. He had a large family and Louis-Claude, in a letter written in 1742 to his former *maître*, Edmé Bouchardon, mentions that he has made a portrait of De Troy's young son.[48] Other than this passing reference, however, no details are known of what was, presumably, a bust. De Troy's numerous children were all fated to die at an early age and he had lost two young sons in 1741.[49] It would appear that the Vassé portrait was of the Director's last, briefly surviving, son who was to die later that same year. The bust thus served two

purposes by preserving the likeness of the boy and also by giving Louis-Claude an opportunity to create an original work.

It was not until 1757, when Vassé had long been back in Paris, that the earliest, dateable marble head of a child was carved, the *Enfant à la tête drapée d'un fichu* which, due to its presence in the prestigious Jacques Doucet collection earlier this century, is the best-known of Vassé's child portraits and stands as a criterion in any study of this group of busts (Fig.2). It is a masterly and tender portrait of a very young girl whose face, although soft with infancy, already has character. She is a particular child and not pretty in the conventional sense – the eyes are narrow, and the nose is pointed and *retroussé*; in the delicately-shaped mouth, the upper lip protrudes over the lower. Her head is encircled by a long scarf, one end of which falls to her right shoulder and so, in an inventive concept, the child's face emerges appealingly from a frame of soft folds, the hair concealed except for a thick fringe on the forehead and a stray wisp or two at one side (Fig.4). Her expression is serene; she is still and involved but there is an impish gleam in her eye. There is an affectionate observation of the child's soft folds of flesh on the back of her neck, showing an intimate knowledge of the sitter (Fig.3).

This is the only signed and dated version (Appendix I,2a) and its silky, luminous surface strikingly displays Vassé's technical skill: to cite just one passage, the slim space between the loose scarf and her right cheek is achieved by undercutting the marble up to a depth of five centimetres between the two surfaces.

The sculpture's whereabouts, after its sale in 1912, were unknown until it surfaced in France recently, and it is now in the Caen Museum. Two other marble versions of the subject are known, neither of them signed (App.2b,2c) but, in the second of these, the carving is dry and the detail coarse and it must be

presumed a workshop version, at best (Fig.7). There are two terracotta versions of the *Enfant au fichu*, neither of them signed, showing major variations from each other – in the tilt of the head, in the hair and in the folds of the headscarf, for example. The first (Fig.6, App.2d), a vigorously-modelled clay with a fresh surface, is very close to the Doucet marble, even to the back of the neck (Figs.3,5) and it is probably the direct model for it. The second, with a bland surface and less definition, appears to be a cast, with variations, of the marble or the terracotta model (Fig.8, App.2e).

Another marble portrait of a young girl, acquired by the Huntington Art Collection of San Marino, California, in 1978 is the *Buste de jeune fille, les cheveux relevés par un ruban* (Fig.9, App.5b). This child is somewhat older, probably eight or nine years, and beginning to show an adult determination in her face. Her head is slightly upturned, chin jutting forward, and her hair is caught cleanly up from her forehead and high on her head by a wide ribbon before falling in short ringlets at the back. The carving is again masterly, the detail crisp, giving an impression which is both lively and spontaneous. Although signed, it is, unusually for Vassé, not a dated signature. Its provenance is brief and there is, apparently, no record of it before it was in the collection of Joseph E. Widener of Philadelphia, certainly by the 1920s. The *Jeune fille, les cheveux relevés par un ruban* was not known to Réau when he wrote his 1930 article and he indicated, wrongly, that Widener had acquired the 1757 *Enfant au fichu* at the Doucet sale. This lack of information on the history of the Huntington marble is to be regretted because it is one of the finest of the Vassé child portraits. It is probable that a second version in marble of this subject was exhibited in Paris at the Galerie Sedelmeyer in 1894, unfortunately not illustrated in the catalogue but described as '*Petit buste de jeune fille marbre, portant les*

cheveux relevés et maintenus par un ruban', and as signed and dated 1763 (App.5a). It was loaned to the exhibition by Paul Lebaudy and appears not to have been seen or published in the last century.

The Huntington bust of a young girl may be compared with a third child portrait, *Buste de fillette à l'épaule drapée*, also unknown to Réau. There are two marble versions of this subject but one (App.4b), which appeared, unattributed, in a Monaco auction sale in 1982, displays a dryness and blurred detail similar to 'App.2c' and may be from the hand of the same studio *praticien*. A second, finer marble (Fig.10, App.4a) was sold at auction in New York City in 1970, with a provenance from a Paris collection. Unsigned, it was correctly attributed in the catalogue to Louis-Claude Vassé, probably on the basis of verbal tradition. At first glance, this bust could be a variant version of the Huntington marble, with one shoulder draped and with the hair carved differently and in a stiff and cold manner, the technical lapse often found in Vassé's larger marble sculpture. However, a more careful examination shows that, although the sitter's features are similar and the hair held up and back, this time by a folded kerchief, she is obviously younger than the Huntington girl and aged about four years. One recognises, in fact, that this is an earlier portrait of the same child - the shape of the eyes, the nose, the delicately-formed mouth, all indicate this and, more conclusively, in each instance the shape of her exposed right ear is almost identical. Superficially, the 1894 catalogue description of the Lebaudy marble exhibited in Paris could also be applied to this portrait. However, the use of the term *'jeune fille'* to describe the child, rather than *'fillette'* and also *'maintenu par un ruban'* when here it is clearly a folded kerchief in her hair, makes this identification unlikely. Further to this persuasive evidence that the

Huntington's *Buste de jeune fille* and the New York *Fillette à l'épaule drapée* portray the same girl at different ages, comparison with the earlier, well-known head of the *Enfant au fichu*, shows convincingly that this, too, is the same child, as an infant. Here the nose, mouth and chin are babyish but have the same characteristics (compare Figs.9,12). It must be concluded, then, that Louis-Claude Vassé modelled, and carved marble busts of, the same little girl on three occasions over a period of seven or eight years. The inference is that she was his own daughter or, at least, a child growing-up close to him.

Louis-Claude Vassé married Marie-Anne Huet de Lepine-Loinville *'who lives on the rue Saint-Honoré in the parish of Saint-Eustache'* on 14 November 1749[50] and the couple had three children. The *acte de naissance* of their elder daughter, Adelaide-Jeanne, in the Archives de la Seine, shows her birth-date to have been 5 April 1755. The two dated portrait busts which have been discussed above are the *Enfant au fichu*, dated 1757, depicting an infant girl about two years old and the *Jeune fille portant les cheveux relevés*, dated 1763, of a young girl about eight or nine years old. Thus, the age which may be presumed for the child, in each instance, reflects the age of Adelaide-Jeanne for each year. The third, intermediate, study similarly poses no age problem, if it is accepted that the child is Adelaide-Jeanne Vassé, and may be dated, consequently, circa 1759. Allowing that the carved date on a marble version may not necessarily indicate the date of the original model, this evidence of no less than three portraits, at three different ages, coinciding with the age of Adelaide-Jeanne, must be persuasive that the identification of the little girl is sound.

Turning to the remaining child portraits by Louis-Claude, the available documentation suggests that only one bust of a boy was executed in the decade or so between 1757 and 1769, during which

period he exhibited child portraits at the Salon. Confusion about the sex of this child, aged about four years, is apparent in many catalogue entries, commencing in 1899, when a marble version, dated 1767, from the Talleyrand collection, was sold in the aforementioned, one-lot sale as a *'Buste de fillette'* (App.3b, Figs.29–31). Réau compounds the confusion further by calling the child *'Une fillette'* in the captions to two illustrations of the subject and *'un garçon'* in the text.

The Musée de Lyon, which owns a second marble, signed and dated 1759 (Fig.11, App.3a), continues to use the title *Buste de fillette* in its most recent guide-book. That it is a boy is obvious and Réau notes that the model appeared, described as a boy and paired with the bust of the little girl in a headscarf, in both the Aranc de Presle (1792) and Robit (1801) sale catalogues – in the latter it is described as *'un jeune garçon d'une figure riante'*. It is one of Vassé's most felicitous child subjects. Evidently pleased with the successful use of a headscarf in the *Enfant au fichu*, Louis-Claude here uses a turban-like cloth which encircles the head but leaves the boy's hair loose in front and falling in abundant, springy curls onto the neck. His head is turned alertly to the left, as if something has just occurred there to catch his attention. His expression is bright and a slight smile deepens the dimples in his cheeks. The shoulders are well-defined, the chest softly muscled. Again, the portrait conveys the personality of a lively child and the device of having him look sharply away from the viewer, although not uncommon in portrait busts of the period, here emphasises the restless curiosity of a young boy.

There are at least three marble versions of the *Garçonnet au turban*, an indication of its popularity. The Lyon bust is the earliest dated example and its date, 1759, is significant. Réau states categorically that it was this marble which was exhibited at the

Salon of that year while Seznec and Adhemar, in their annotated studies of the Diderot Salons, assume that it was the 1757 marble version of the *Enfant au fichu* which Vassé exhibited and illustrate that bust as No.126 in the *livret*.[51] There is, however, much to support Réau: an *amateur* described the 1759 Salon *'tête'* as *'most beautiful and with an air of mischief'* and this describes the Lyon boy perfectly while the *Enfant* of 1757, although she has a touch of impishness, is too young to fit that description.[52] Furthermore, the Lyon bust, unusually, is signed twice: *'Vassé'* on the truncation under the left shoulder and 'VASSÉ 1759' on the foot, which is persuasive evidence that the sculptor set the bust on a new socle which he signed and dated for the purpose of exhibiting it in the Salon of that year.[53]

If it is accepted that Louis-Claude executed portraits of his elder daughter, it seems logical to consider the *Garçonnet au turban* as a portrait of his only son, Pierre-Louis Vassé, called Louis. A major problem in confirming this is the fact that Louis' *acte de naissance* is one of the many documents which have been destroyed in various civic disorders in Paris. However, there are others extant which indicate his age. One is the record of Louis-Claude's burial, in the parish of Saint-Germain-l'Auxerrois, dated 1 December 1772, which states that this was in the presence of *'Sr Louis Vassé, bourgeois de Paris, son fils; de Srs Pierre-Henri Martin, architecte juré expert du Roy et de Claude Bacarit, architecte des batiments du Roy, ses beaux-frères'*.[54] The title 'Mr. Vassé, citizen of Paris' does not suggest a child yet the lack of a named profession indicates that he had not yet achieved one. More helpful is an expert's report of 11 April 1774, which refers to *'le sieur Louis Vassé, étudiant en architecture'*, and also to his two sisters, as *'mineurs émancipés d'âge en 1772'*. From this it can be learned that, quite shortly after Louis-Claude's death, the three

children were released by the courts from guardianship and they could control their own affairs although still technically minors. This was only possible after a child had reached fifteen years of age. The report was witnessed by the same brother-in-law, Claude Bacarit, who had collaborated with Vassé in the affair of Saint-Germain-l'Auxerrois and who was, legally, supervisor of the young Vassés' emancipated status. It is apparent from this document that, although young Louis was not yet twenty-one years of age in April 1774, he was old enough to be a student of architecture.[55]

The earliest published marble portrait of the *Garçonnet au turban* is dated 1759 but, as has been suggested, it could have been carved earlier, probably the year before. There is support for this dating: Louis-Claude Vassé was recommended by Caylus to a wealthy lawyer from Troyes, Pierre-Jean Grosley (1718–1785), who wanted to donate as many as sixteen retrospective marble busts of famous sons of Troyes to decorate one of the salons of the city's *hôtel-de-ville*. It was, obviously, an extraordinary commission and, although local politics reduced the number of busts, Vassé exhibited several, including those of Pierre Mignard and François Girardon at the Salons of 1757 and 1761. There was some written correspondence between Vassé and Grosley and, in a letter from the sculptor to his patron, dated 1 March 1758, Louis-Claude wrote: '*I am delighted, Monsieur, that the Bambinello has arrived safely and suffered no damage on the way* …'.[56] It is clear that Vassé had sent to Grosley a sculpture of a little boy[57] and if, as is likely, it was a gift from the sculptor to his patron, it was probably a terracotta version of the *Garçonnet au turban*, his only portrait of a boy recorded for that period. Thus, the original study for this bust could conceivably date from early 1758 which gives an acceptable birth-date for Louis of late 1753 to

early 1754. In this case, he would have been aged about eighteen when he attended his father's funeral in 1772 and aged about twenty at the time of the expert's report, quoted above. Furthermore, in this portrait, even though still a very young boy, Louis bears a distinct resemblance to his father, particularly in the shape of his eyes and the nose, supporting the identification of this child (compare Figs.13,14). Vassé's use of the Italian expression *'bambinello'* (an affectionate diminutive of bambino which he undoubtedly acquired during his stay in Rome) in his letter to Grosley, led to Réau's assumption that the sculptor thought of the carved and modelled infants as surrogate 'babies' but, for a man who already had two young offspring of his own, this is not logical. Vassé's *'bambinelli'*, in my opinion, were his own children.

Louis-Claude and his wife also had a second daughter, Constance-Félicie-Victoire, who was born 20 June 1760. Presuming that the sculptor executed portraits of his two elder children, it is most unlikely that there were no studies of Constance-Félicie. Only one candidate among Vassé's remaining, recorded child portraits may be proposed and this is the most elusive of all. It is a marble carving of the head and shoulders of a tiny baby, wearing a be-ribboned lace bonnet, partly covered by a fringed shawl which goes over the head and is wrapped round the shoulders. The family traits are so evident here that it might be another, earlier portrait of Adelaide-Jeanne but this is unlikely. The eyes are narrow, the cheeks pudgy and she is carved with an uncompromising realism; she is no *poupée* (Fig.15, App.6a). It is, however, not Louis-Claude's most successful child portrait and the fussy details of the bonnet and shawl overwhelm the tiny face of the infant. Unfortunately, the knowledge of this marble baby resulted in the attachment of Vassé's name to certain over-elaborate nineteenth-

century marble and terracotta pastiches of 'eighteenth-century' infants of mediocre quality, casting an undeserved shadow on his reputation.[58] Vassé's *Petit enfant au bonnet et au châle* is presently known only from its illustration by Dreyfus in an article on the collection of Mme Louis Stern[59] and also by Réau, by which time it had passed to M. Jean Stern.[60] Although it is unsigned, both authors accepted the carving as by Vassé. The *Petit enfant* may be dated circa 1760–61, if the identification proposed here is accepted. Logically, such a carving would have been executed to remain in the Vassé home; at the time, it would have been too personal and its appeal too limited, to be of interest outside the immediate family circle.

The Stern marble bust of a baby is the last of Louis-Claude Vassé's sculptures of children which may be identified as portraits of the sculptor's own offspring. It cannot be coincidence that, for ten years after Vassé returned from Rome to begin an active career as a sculptor in Paris, there is no evidence that he executed any sculptures of children, even though he had a twelve-year-old niece, Anne Sachit, living in his home for a time until August 1756[61]. Conversely, commencing about 1757, by which time his own two older children had grown beyond babyhood, the series of portraits which have been identified here as Vassé children was executed quite briskly, over a comparatively short period, until 1763, while they were all still quite young.

There is no record of any succeeding child portrait by Louis-Claude having been executed before 1770, the date of a fine marble bust which is larger than any of the previously-discussed portraits. The *Buste de jeune fille aux frisettes* is almost waist-length (Fig.16, App.7a). The subject of the sculpture is about ten years old, and is, in this instance, a conventionally pretty child, with wide eyes and a straight nose. Moreover, she is portrayed in

a manner more typical of the eighteenth century, rather like a miniature lady of the court, with carefully-coiffed hair, held by a ribbon, in curls behind the head, with the customary single long ringlet falling to one bare shoulder and wearing a classical, loose robe held in place by a ribbon over the same shoulder. The formality of this portrait, in contrast to the spontaneity of the busts of the Vassé children, noted above, indicates that it was a commissioned work. Even the sculptor's treatment of the marble is less personal than in the earlier carvings; his tendency to hardness is missing here and the details are delicately suggested.

This delightful sculpture, once in the collection of George Blumenthal, was sold at auction in Paris in 1989 and the excellent price it made brought to light an unpublished, plaster version of the same subject, with some variation in the coiffure, which was offered for sale later in the same year (App.7b). The appearance of such a large and important Vassé plaster, unknown in the literature, as recently as 1989, is a promising indication that other unrecorded works by the sculptor may yet be found in private collections in France. The last bust which can be cited here is minor: a plaster head of a young boy with large eyes and wavy hair, modelled cursorily. It is signed and dated 1771, a year or so before the sculptor's death and is a return to the informality of the earlier busts (App.8).

What these two late busts give evidence of, particularly, is that the recurring facial features of those portraits identified here as the Vassé children – 'they all look alike' might, until now, have been a fair, if unkind, comment – were not an idiosyncrasy of the sculptor's observation of every child but were, indeed, family traits. The 1770 *Jeune fille aux frisettes* also demonstrates, by comparison, how the busts of Vassé's own infants, most particularly the two heads of Louis and Adelaide-Jeanne, aged eight, have

a vivacity which was rare for the period until then, giving credence to Benoist's comment, quoted above: 'the liveliest before Houdon'. Happily, there are superb marble versions of these to be studied, side by side, in The Huntington Collection (Figs.9 and 17).[62] They offer a convincing demonstration, not only of Louis-Claude Vassé's technical virtuosity but also of his imaginative approach to the portrayal of his children. Seen with the familiarity of a parent, but with a complete lack of sentimentality, the portraits of his two older children find them, not prettified and posed for the occasion, but caught with an immediacy that is captivating and timeless. Indeed, these charming sculptures may offer us the rare opportunity of seeing how Louis-Claude Vassé worked without somebody directing him from behind.

NOTES TO CHAPTER 2 (numbers 44–62)

44 Réau, p.53: '... le meilleur titre de gloire de Vassé est peut-être la collection vraiment exquise de ses bustes d'enfants, ses *bambinelli*, comme il les appelait, qui annonce et égale parfois les délicieux portraits enfantins de Houdon'.

45 Benoist, p.122: '... les plus vivantes qui existent avant Houdon et qui constituent le meilleur de son oeuvre ...'

46 Paul Vitry, entry for lot 122 in 'Collection Jacques Doucet', auction catalogue, Paris, 6 June 1912: '... bien antérieur aux célèbres figures de Houdon ...'. A few years earlier, Vitry (1903, p.11) had described the Doucet bust at length in an article on the collection: '... sa date de 1757 est à retenir, car nous avons là certainement, soit chez Vassé, soit chez ses contemporains, l'une des premières oeuvres d'une série (of child portraits) qui abondera en morceaux gracieux.' (*one should keep in mind its date of 1757 because we have here certainly, either from Vassé or from his contemporaries, one of the first works of a series which will abound in graceful pieces.'*)

47 Vassé exhibited child subjects three times in the Salons: in 1759, the *livret* lists '126. *Une tête d'enfant en marbre*'; in 1763, it lists '169. *Une tête d'enfant*' (i.e. not in marble); in 1765, it lists '200. *Une tête d'enfant en marbre*', generally accepted to be a marble version of the 1763 model. (Seznec and Adhemar, vol.II, p.47: 'Personne ne parle de la *Tête d'enfant*, dont le modèle avait été exposé au Salon de 1763 ...').

48 Roserot, p.152, cites this letter, adding: '... je ne crois pas que cette sculpture ait jamais été signalée et reconnue parmi les quelques jolis bustes d'enfants qu'on connait de Vassé. (*'... I do not think this sculpture has ever been indicated and recognised among the several known pretty busts of infants by Vassé.'*)

49 Levey, 1965, summarises the dismal history of De Troy's family.

50 Arch. Nat.(M.C.) et IV.564.

51 Seznec and Adhemar, vol.I, p.57: '... est sans doute le buste d'enfant daté *1757 de l'ancienne collection Doucet.*' (The bust is illustrated, as fig.108.)

52 *Lettre critique à un ami sur les ouvrages de MM de l'Académie exposés au Salon du Louvre*, Paris 1759, p.29. Seznec and Adhemar, vol.I, p.57, also cites the comment of the *Journal Encyclopédique* on this head: '*pleine d'esprit*' which, again, suggests the Lyon boy, rather than the *Enfant au fichu.*

53 Vassé's signature on tne socle of this bust of 1759 is carved in a manner identical to that of the signature on the important *Nymph of Dampierre* of 1763, illustrated in Souchal, 1977, fig.6.

54 Archives Nationales (M.C.) et CXIII, liasse 344.

55 The document is quoted by Stein (p.415): '... un rapport d'expert que possèdent les Archives Nationales (A.N.Z. 7250) ... "L'an mil sept cent soixante quatorze le lundy unziesme jour du mois d'avril ... réquisition par Dame Marie-Anne Huet de Lepine-Loinville, veuve du sieur Louis-Claude Vassé ... le sieur Louis Vassé, étudiant d'architecture, la damoiselle Adelaide-Jeanne Vassé, et la demoiselle Constance-Félicie-Victoire Vassé, frère et soeurs, tous trois enfans dudit sieur et dame Vassé, mineurs émancipés d'âge par lettres obtenues en la chancellerie du palais à Paris le douze décembre mil sept cent soixante douze ...".' The expertise related to the value of Vassé's house which he had bequeathed to his three children. Presumably, young Louis was studying architecture with his uncle but he is not recorded in any French dictionary of architects. His death certificate, like that of his birth, has been destroyed but a deed of inheritance, leaving his estate to his two sisters, is dated 19 October 1785, when he would have been in his early thirties. (Archives de Paris, D.C^6 29, folio 171).

56 The letter is quoted by J. Pierre, p.89: 'Je suis bien charmé, Monsieur, que le Bambinello ait été bien reçu et qu'il soit point mutilé chemin faisant ...'.

57 Salvatore Battaglia, *Grande Dizionario della Lingua Italia*, Turin 1962, vol.II, p.29, cites *il bambinello, la bambinella, due bambinelli*, as current diminutives of bambino (cf. section 8).

58 For example, a much-reproduced bust of a small girl in a ribbon cap with lace border, at one time attributed to Houdon, was suggested by Vitry to be by Vassé, an attribution not rejected by Hodgkinson. This vacuous, doll-like child, however, is not by Vassé (ref.: *The Frick Collection Catalogue*, vol.IV, New York 1970, pp.146-148.) Benezit's entry for Vassé cites a marble draped head of an infant in the Musée de Bernay but this unpleasant and crude sculpture is far from Vassé's style and period. Another marble child's bust incorrectly given to Vassé was in the Alphonse Kann sale in Paris, 6–8 December, 1920, lot 181, illustrated; here the heavy features and strangely-curled hair relate more to several French or Flemish children of the period, two of which appeared at the Palais des Beaux-Arts, Brussels, 24 March 1981, lot 679, illustrated.

59 'Le joli petit buste en marbre qui nous montre cet enfant sérieux et joufflu … ne nous parait pas être de Houdon … mais plutôt de Vassé qui executa plusieurs de ces charmants petits portraits d'enfants.' Dreyfus, see 'App.6'.

60 Réau, p.54, fig.14.

61 Apparently, Anne Sachit, the young daughter of Vassé's sister, chose to reside with Vassé and his wife against her parents' wishes. A court order of 28 August 1756 was enforced, returning her to her home. This odd situation is recorded in a retrospective 'gossip-column' in the *B.S.H.A.F.*, 3ᵉ Année, January 1877: '*Variétés: Notes sur la vie privée et les moeurs des artistes au XVIIe et au XVIIIe siècles*', a compendium of less than sensational stories concerning delinquent patrons, thieving domestics and the like.

62 These two busts were united by Mrs Mildred Browning Green, whose adviser was W.R.Valentiner. She bequeathed them to The Huntington in 1978. (I am grateful to R.R.Wark, former Curator of the Huntington Art Collections, for this information.) Earlier, Dr Valentiner had been a co-cataloguer of the Joseph E.Widener Collection and thus may have initiated the sale of the Vassé *Adelaide-Jeanne* to Mrs Green.

Sculptors in the Nursery: From Pigalle to Houdon

THAT Louis-Claude Vassé's sculpture studies of his own children were innovative is not difficult to demonstrate. Nevertheless, there had been one or two earlier examples to be seen in the Paris Salons, pointing to a new trend away from the formal portraits of children as mini-adults, considered *de rigeur* until then. The first, and best-known, was Jean-Baptiste Pigalle's *Enfant à la cage*, carved in 1749 and shown at the Salon of 1750. Although, understandably, it had an immediate success with the critics and was widely admired, its equal significance lay in the fact that it was a commissioned portrait, not an anonymous, cuddlesome baby. The *Enfant* was the son of a powerful court banker and *'receveur des rentes de la Ville de Paris'*, Jean Pâris de Montmartel, Marquis de Brunoy (1690–1766), who was also the godfather of Mme de Pompadour.[63] In a delightful engraving of the period, Pâris is shown, seated in his opulent *cabinet*, next to Pigalle's marble statue of his infant son, now in the Louvre. The realism and the masterly simplicity of his carving of the naked baby, however, are overwhelmed by being set in an elaborate

gilt-bronze mount and posed on an equally fussy table (Fig.19). An early model for Pigalle's *Enfant*, lately discovered, has revealed that the sculptor originally considered showing the baby with a dead bird at his side, strangled by the thin cord of a toy perch, also shown on the base, with which the infant boy has been playing (Fig.20).[64] This suggestion of guilt, however, may have been carrying realism too far for Pâris de Montmartel and the eventual marble baby, head turned in innocent dismay at a bird that has flown its cage, may well have been the father's, rather than the sculptor's, preference. There were to be other sculpted babies from Pigalle's chisel but these never achieved the genius of the first *Enfant*: anonymous children, they are depicted grasping a live bird or weeping over a dead one – it was an association which seemed to preoccupy this sculptor. Pigalle liked the 1749 marble so much that he bought it back in 1776 at the sale of Pâris de Montmartel's estate, at which time Diderot wrote to Grimm that the *Enfant à la cage* was *'the finest thing (Pigalle) has done'*.[65]

By coincidence, Jacques Saly's moody little girl with braided hair, which continued the unsentimental approach with an older child, was also exhibited in the 1750 Salon (Fig.18). Again, this is a portrait but, over the years, her identity changed according to prevailing theory and, for a long time, she was called Alexandrine d'Etiolles, the daughter of Mme de Pompadour.[66] In 1965, Michael Levey proposed, persuasively, that the bust was a portrait of Jean-François De Troy's last surviving daughter which would make her the sister of Vassé's first child sitter.[67] As has been noted, Jacques Saly (1717–1776) was a *pensionnaire* contemporaneously with Louis-Claude Vassé[68] and the two sculptors arrived in Rome within a few months of each other. There is an ongoing thread, linking Saly's bust of the sad Mlle De Troy with the child portraits of Vassé. Levey hypothesised that Saly's portrait was carved after

46

the death of her last surviving sibling in 1742 but it is also possible that the two young sculptors, encouraged by De Troy, each modelled a bust of one of his children early in 1742. Some years later, marble versions of Saly's *Fillette* and Vassé's *Garçonnet au turban*, were considered pendant in one major eighteenth-century French collection, that of Thiroux d'Epersennes, a wealthy collector of sculpture and patron of Falconet, who had visited Rome while Saly and Vassé were there, at the Académie, and saw the work of the two young sculptors.[69] That he brought back Saly's bust with him to Paris was recorded by Mariette – the De Troy boy may have died by then, which would have discouraged the acquisition of Vassé's portrait of him.[70]

A few years after, however, Thiroux evidently purchased a marble bust of young Louis Vassé from his father and from then on, for Thiroux, the two child portraits were linked. They appeared in his *inventaire après décès* of 1767 and were bequeathed to a Mme d'Arconville, after which there was no trace of them, according to Babelon.[71] Nevertheless, there are marble carvings of these two busts, long-separated but set on similar, distinctive socles, which are probably the Thiroux d'Epersennes 'pair' – which he had related even more specifically by having matching socles carved for them: one is the San Marino *Garçonnet au turban* and the other is a Saly *Fillette* which was in the David-Weill collection in Paris in 1945 (Figs.17,22).[72] The relationship between these two sculptures has not previously been perceived and it adds support to Levey's hypothesis that the little girl is Mlle De Troy. Saly's portrait of her, although pouting and *triste*, has a particular appeal with its attractively-braided hair and he was apparently encouraged to execute several examples in different materials. Boucher also used her image in drawings and wall-panels representing 'Sculpture'. On occasion, inept Paris

'experts' have catalogued Saly's *Fillette* as the work of Vassé.[73]

In 1950, Réau cited Pigalle, Bouchardon, Vassé and Houdon as *'the most delightful sculptors of children in the eighteenth century'*.[74] Edmé Bouchardon's children are indeed individual – sturdy, mischievous and usually naked, they pursue their playful activities or ride his sea-monsters with a human determination, more natural in concept than the winsome putti which usually performed such functions. However, there is no point of comparison between these anonymous inhabitants of a never-never land and the child portraiture which is under discussion.

Réau, obviously, did not recall that, in 1922, he had written in his monograph on Etienne-Maurice Falconet: *'one forgets that there are also the Enfants Falconet and that as a sculptor of children our artist has few equals among his contemporaries'*.[75] Falconet's models of children for the Sèvres *biscuit* statuettes and groups which were so deservedly popular in the second half of the eighteenth century may, like the children of Bouchardon, be *hors catégorie* when considering child portraits. Nevertheless, if there are any contemporaneous parallels to Vassé's vision of his own offspring, they are to be found in Falconet's figures of insouciant peasant children which he modelled after Boucher. These infant 'gardeners', 'shepherdesses' and 'pedlars' could be, and were, represented with an unconventional freedom not normally permissible for a child of the nobility or even of the *bourgeoisie* and their unruly hair, knotted kerchiefs and lack of self-consciousness mirror the realism with which Louis-Claude portrayed little Adelaide-Jeanne and Louis (Fig.21). The original drawings of the *'enfants Boucher'* date from about 1750 and engravings of these were widely available. Falconet's involvement with the Sèvres factory commenced in 1757 and his name is attached to many of the figures modelled after Boucher, although other sculptors

followed him. Their appearance is, therefore, contemporary with Louis-Claude Vassé's first sculptures of his own children.

Although Jean-Baptiste II Lemoyne modelled a few heads of children which appear to be portraits, they do not create a body of work which has drawn attention to this aspect of the sculptor's brilliance as a portraitist. The most apposite example, for the present study, is a delightful head of a little girl, dated 1769, wearing a scarf tied closely round her face and knotted on the top of her head. She has a lively, piquant expression and the immediacy of the sculptor's representation of her is strongly reminiscent of Vassé's portraits of Adélaide-Jeanne (Fig.23). As Gaborit has noted, Lemoyne had exhibited a similar child's head in the Salon of 1761 (now lost but sketched by Saint-Aubin in his *livret*)[76] and he may have been familiar with Vassé's *Enfant au fichu* of 1757. In a terracotta study of a small girl, which was also in the David-Weill collection, he reverts to formality, albeit in a sketchy fashion, with the hair piled on top of the head and a single ringlet falling to one shoulder in the convention of the period[77] but Réau, in his monograph on Lemoyne, could not attach a name to any of the few child subjects he was able to catalogue. As a portraitist, Jean-Baptiste II Lemoyne had no peer and it seems unlikely that he did not model some studies of his own offspring. He was married three times and had eight children between 1740 and 1751, four of whom died in infancy.[78] Possible candidates for studies of young Lemoynes are two little-known terracotta sketches of the heads of a small girl, aged about five years and a small boy, about a year younger, who are obviously sister and brother. Given their loose treatment and small scale (24 cm high), it is tempting to identify them as portraits of Marie-Thérèse Lemoyne, born in 1747 and her brother Pierre-Hippolyte, born in 1748. These were listed by Réau in 1927, without any details, as

being in the collection of Octave Homberg of Paris[79] and in 1931 they appeared in the important auction sale of the Homberg collection, illustrated in the catalogue (Fig.24).[80]

Jean-Baptiste Houdon carved the first of several portraits of his three daughters, the oldest child, Sabine, when she was aged ten months (Fig.25). As has been remarked above, it has not been infrequent in the literature to refer to the child portraits of Louis-Claude Vassé as the precursors of Houdon's famous sculptures of his children[81] and it would be surprising if Houdon was not familiar with Vassé's busts although the last appearance of one of them in a Salon was in 1765, when Houdon was still a *pensionnaire* at the Académie in Rome. However, if there was no direct influence on the younger sculptor, there was a more specific analogy between the two groups of infants, unrealised by the many writers who related them: it is that, in both instances, they were portraits of the sculptor's own children, seen with the affectionate eyes of a father. This cannot be said of any of the other fully-achieved infants' portraits which have been discussed above.

In his major monograph on Houdon, Réau wrote that the sculptor made three portraits of Sabine while she was still a young child but this is erroneous. The second of these, supposedly of the little girl, aged two, was apparently a unique work to be found in Russia in the 'Palais de Gatchina'.[82] In fact, this sculpture was Houdon's *Anne Audéoud*, a subject illustrated by Réau in his catalogue, who is obviously much older.[83] The most popular (and much-reproduced) portrait of Sabine was as a four-year-old (Fig.26) and in this bust, particularly, Houdon follows Vassé in showing the child informally, the hair not coiffed in a style specifically of the period and her body bare of any costume. Consequently, *Sabine* is atemporal and it is not surprising that

her appeal has proven to be universal, rather than that of an eighteenth-century artefact. Houdon modelled busts of his two younger daughters only once in each instance: Anne-Ange, aged fifteen months (Fig.27) and Claudine, aged one year (Fig.28) for, like Louis-Claude Vassé, he favoured his first-born in the number of portraits achieved.[84] Unlike Vassé, however, Houdon did capitalise on the popularity of his child studies, not only those of his daughters but also the two appealing busts of Alexandre and Louise Brogniart. According to Vitry, Houdon's need for money pushed him to this commercialisation from about 1790.[85] For whatever reason, the many authorised versions, followed inevitably by reproductions of varying quality, gave them an exposure which has led to their well-deserved status as icons of childhood.

Vassé's sculptures of children, in contrast, have always been and continue to be far less evident:[86] in the major Paris exhibition 'Portrait et Société en France (1715–1789)' at the Palais de Tokyo in 1980, for example, in which there was a good section on 'Les enfants',[87] there was no Vassé child although the curator of the sculpture exhibits, Michèle Beaulieu, had noted their significance just a few years before[88] and they are, after Houdon's, the most important body of such works executed by a sculptor in the period covered. The exhibits, however, were drawn from three participating Paris museums, including the Louvre, none of which has a Vassé child portrait in its collection.[89] In fact, to my knowledge, sculptures of this genre by Louis-Claude Vassé are to be seen in only two French museums, Caen and Lyon.

As a perusal of the literature will demonstrate, it is not an exaggeration to say that Vassé's children are less appreciated now than they were in the first half of this century: in Michael Levey's survey of French eighteenth-century sculpture, for instance, referred to earlier, he discusses Saly's little girl at some length in

his section on that sculptor and, of course, gives several of the Houdon child portraits his attention but, in his appraisal of Vassé's sculpture, the portraits of children are not mentioned.[90] Yet, as has been demonstrated in this study, they were an early manifestation of the changing vision of children by French artists through the eighteenth century and a significant contribution to it. They show us Louis-Claude Vassé at some of his finest moments as a sculptor and it is time that they were more widely-known.

NOTES TO CHAPTER 3 (numbers 63–90)

63 The commissioning of the *Enfant à la cage*, as a pendant to a life-size 'antique' marble statuette of a baby girl, holding a bird, which was already in Pâris de Montmartel's collection, is described by Dubois-Corneau (p.328 et seq.).

64 Bresc-Bautier, no.20: 'Un premier projet, abandonné pour sa tristesse, montrait l'oiseau mort, à coté de l'enfant'.

65 Diderot to Grimm, 13 December 1776.

66 M.N.Benisovich, 'A bust of *Alexandrine d'Etiolles* by Saly', pp.30–42, *Gazette des Beaux-Arts*, 6th series, vol.28, July 1945; refuted by M.Beaulieu, *B.S.H.A.F. année 1955*, Paris, 1956, p.62 et seq.

67 Levey, 1965, p.91.

68 *Correspondance*, vol.IX, p.417, no.4263.

69 Babelon, p.101.

70 Ibid. Also Jouin (p.110), who writes that Saly's bust was intended as a gift for De Troy (which could have been the case for Vassé's portrait, too) until Thiroux expressed a desire to own it.

71 Babelon, p.109, first lists the Saly bust and then the Vassé bust of a boy, 'formant la paire avec la tête de jeune fille de Saly ... L'oeuvre figure dans le testament de 1764, l'inventaire (after death) de 1767 pour la somme de 300 livres ...' but it is not clear whether this sum was for one or both busts.

72 Benisovich (op.cit., note 61), p.35, fig. 5.

73 Paris, 9 March 1972, lot 97 (ex. Colln. Cote-Rébé, Paris, 17 March 1933, lot 25), a misattribution which is perpetuated by Benezit, *Dictionnaire*, Nouvelle Edition, Paris, 1976, vol.10, p.407.

74 Réau, 1950, p.106: '... les plus délicieux sculpteurs d'enfants du XVIIIe siècle ...'.

75 Réau, 1922, vol.I, p.25: 'on oublie qu'il y a aussi les Enfants Falconet et que comme sculpteur d'enfants notre artiste a eu peu d'égaux parmi ses contemporains ...'.

76 Gaborit, 1984, p.64.

77 Réau, 1927, plate LXXVIII, fig.122.

78 Ibid, p.47.

79 Ibid, p.153, no.163.

80 Paris, Galerie Georges Petit, 5–7 June 1931, lots 281, 282, illustrated plate LXXXVIII.

81 Most recently: Beaulieu, p.92; also Gaborit, 1987, p.39.

82 Réau, 1964, vol.I, p.418: 'De sa fille aînée Sabine, pour laquelle il semble avoir eu une prédilection, Houdon a fait quatre portraits: à l'âge de dix mois (1788), de deux ans (1789), de cinq ans (1791) et de quinze ans (1802) … Le portrait de Sabine à deux ans a émigré au Palais de Gatchina dans les environs de Leningrad.'

83 A. Troubnikoff in 'Les vieux portraits d'un vieux château', *Starvie Ghodui*, 1914, II, p.84 et seq., illustrated the plaster bust at Gatchina as 'Sabine Houdon (?)' – the query was well-advised because Houdon's *Anne Audéoud*, is clearly five or six years old. The date on the Gatchina bust was a not perfectly legible '178?' which Troubnikoff read as 1789 but was probably 1780, the date found on another plaster version of this bust in Schwerin. *Anne Audéoud*, a little girl with straight, fringed hair, wearing a short-sleeved dress, is illustrated in Réau, 1964, plate XXXIX, and in H. H. Arnason, *Houdon*, London, 1975, fig. 128.

84 Arnason (op. cit., note 83) p.84, wrote: 'Houdon made portraits of his three daughters at different ages' which, though essentially correct, may also be interpreted to mean that there was more than one portrait of Anne-Ange and Claudine, which is not so. Similarly: Dijon, Musée des Beaux-Arts, *Portraits sculptés XV–XVIII siècle*, 1992, p.70, no.27, entry by G. Scherf.

85 Vitry, 1906, p.348.

86 The fact that there were a number of marble and plaster *'têtes d'enfans'* in Vasse's studio at his death (App.9a) suggests that these might have been executed for purposes other than family souvenirs or gifts, as with the bust sent to Grosley. However, this category would certainly have included study heads for larger works and there is no subsequent evidence to indicate that the portrait heads were executed in any great number. The long period between the carving of the two dated marble busts of young Louis – 1758/9 and 1763 – is unusual in Vasse's *oeuvre* and suggests that the later version was a particular commission for a repetition of this attractive model.

87 Paris, Palais de Tokyo, *Portrait et Société en France (1715–1789)*, December 1980, included child portraits by the sculptors J. L. Couasnon (1747–1812), Pigalle, Saly and Houdon.

88 Beaulieu, p.92.

89 The two other participating museums were Carnavalet and Versailles.

90 Levey, 1972, p.81; also 1993, p.124.

Illustrations

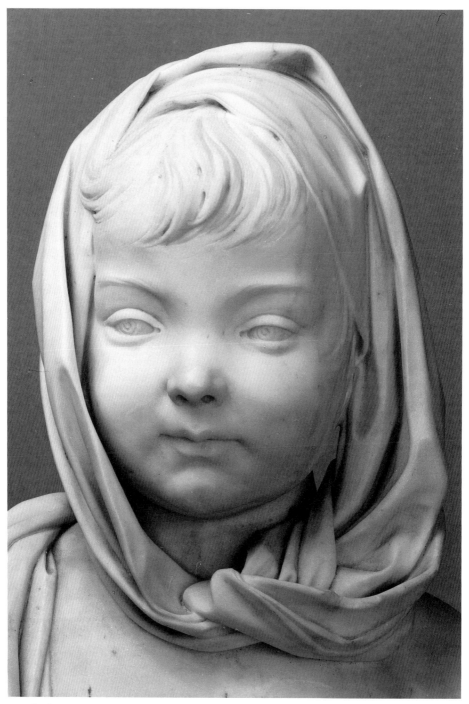

Detail of Fig.2.

Figure 2 Louis-Claude Vassé, *Enfant au fichu*, 1757, here identified as Adelaide-Jeanne Vassé, aged 2 years. Marble (App.2a). Photo: courtesy of Musée des Beaux-Arts, Caen.

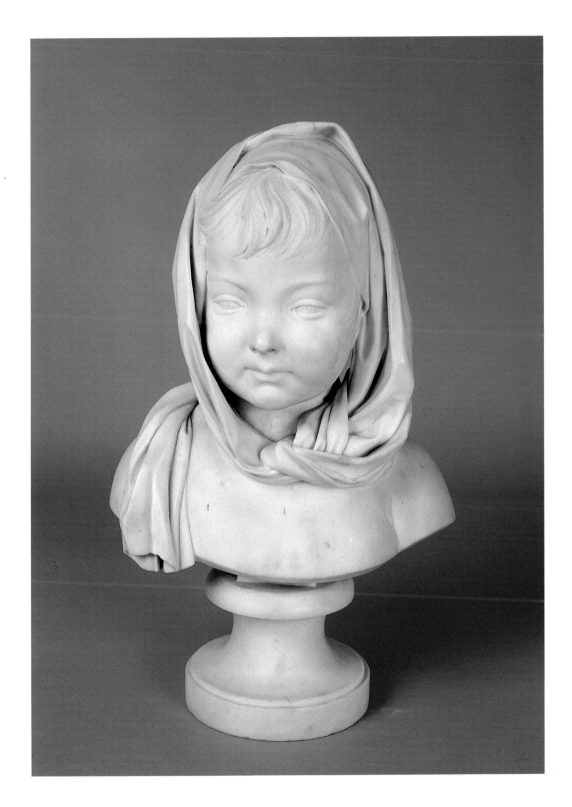

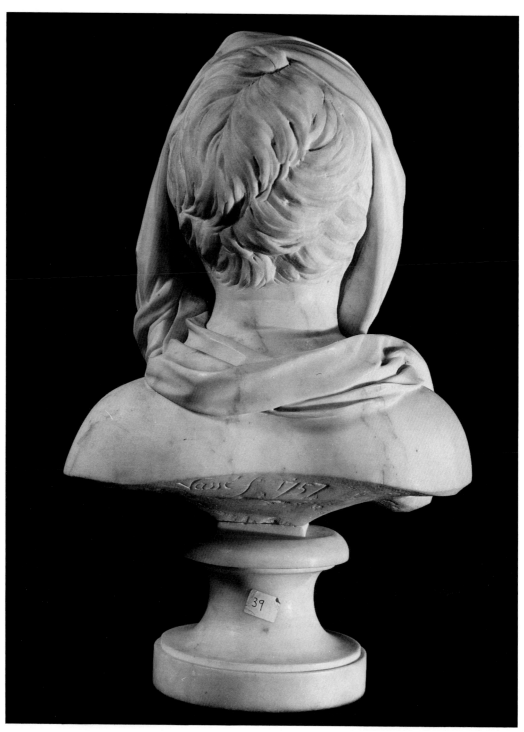

Figure 3 Back view of Fig.2.

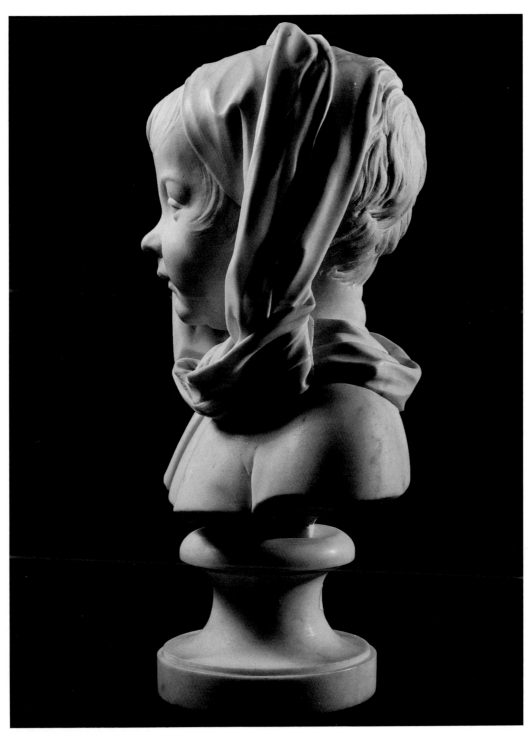

Figure 4　Side view of Fig.2.

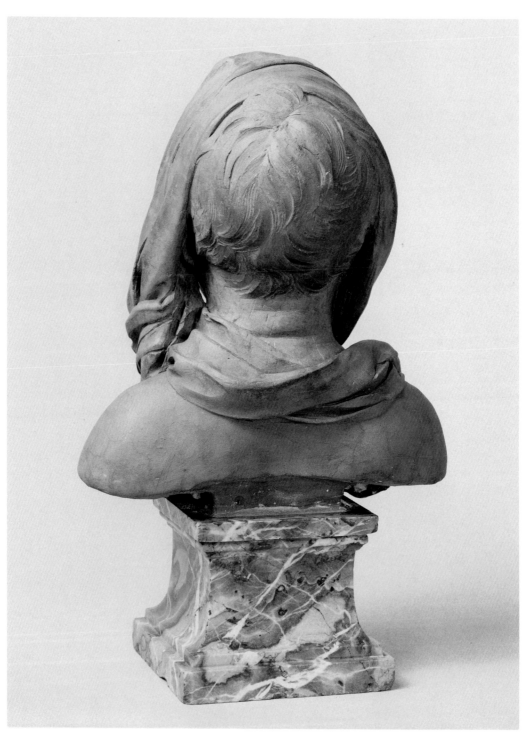

Figure 5 Back view of Fig.6.

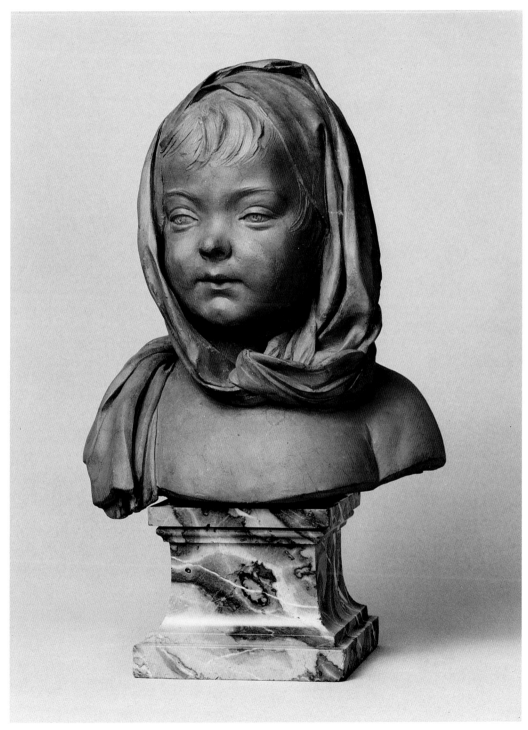

Figure 6 Louis-Claude Vassé, *Enfant au fichu*, circa 1757, terracotta model (App.2d).
Private collection.

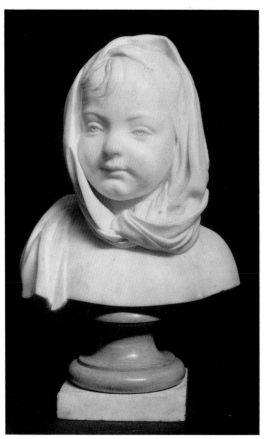

Figure 7 *Enfant au fichu*, marble, workshop of Louis-Claude Vassé (App.2c). Formerly, collection David-Weill, Paris.

Figure 8 *(right)* *Enfant au fichu*, terracotta cast, workshop of Louis-Claude Vassé (App.2e). Formerly, collection David-Weill, Paris.

Figure 9 *(opposite)* Louis-Claude Vassé, *Jeune fille, les cheveux relevés par un ruban*, circa 1763, here identified as Adelaide-Jeanne Vassé, aged 8 years; marble (App.5b). Collection: The Huntington Art Gallery, San Marino, California. The innovative informality of this portrait, not attached to its period by hair-style or costume, gives it a timeless appeal and pre-dated Houdon's well-known *Sabine* (Fig.26) by thirty years.

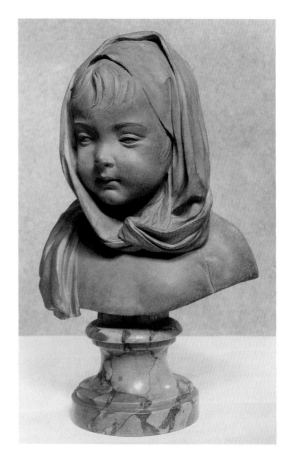

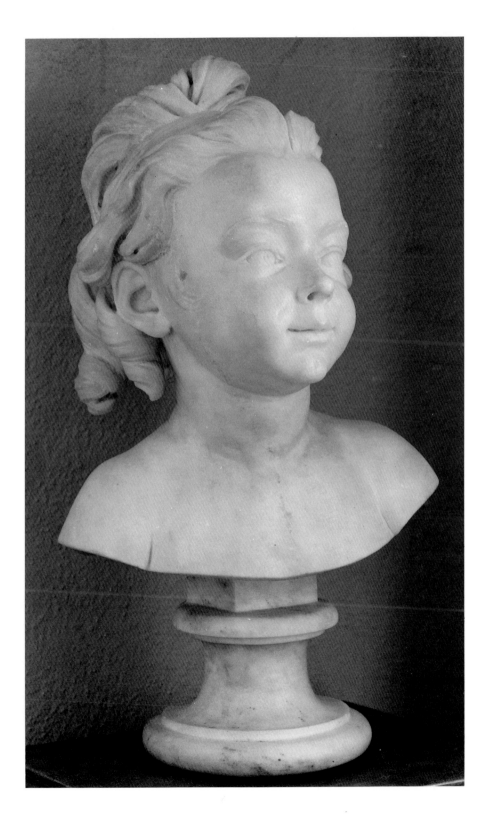

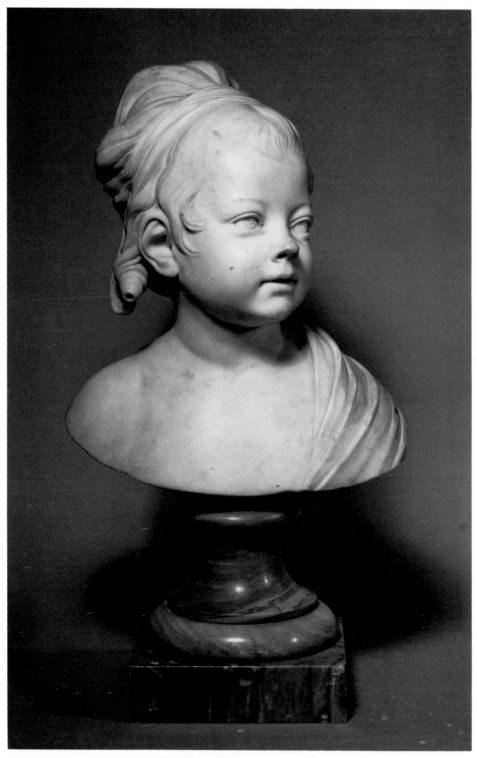

Figure 10 Louis-Claude Vassé, *Fillette à l'épaule drapée*, circa 1759, here identified as
Adelaide-Jeanne Vassé, aged 4–5 years, marble (App.4a).

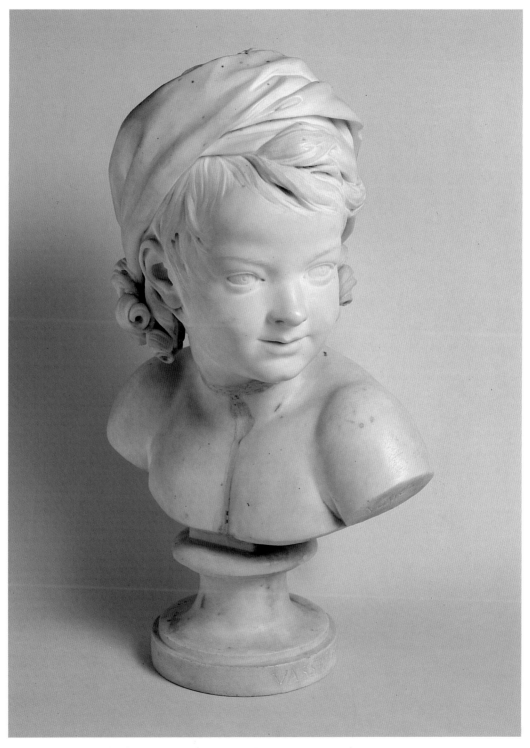

Figure 11 Louis-Claude Vassé, *Garçonnet au turban*, 1758–9, here identified as
Pierre-Louis Vassé, aged about 4 years, marble (App.3a).
Collection: Musée des Beaux-Arts, Lyon.

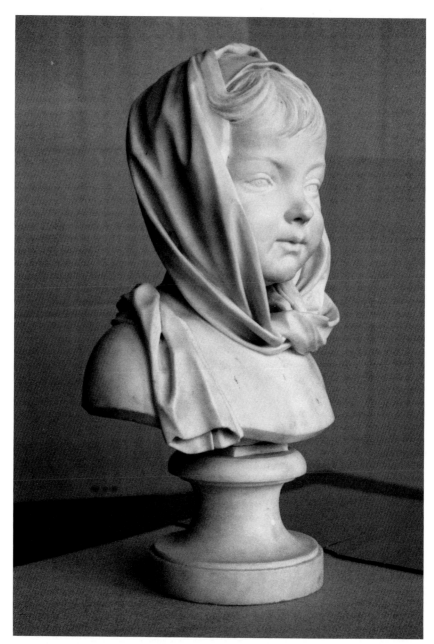

Figure 12 Another view of Fig.2; compare Figs.9,10.

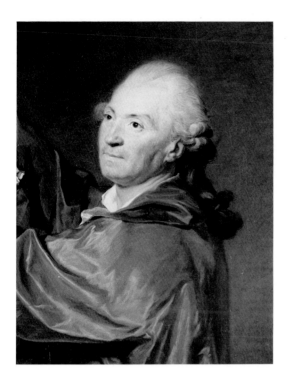

Figure 13 Detail of Fig.1.

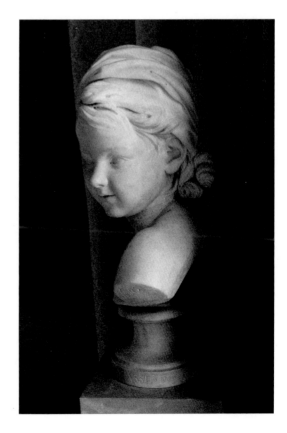

Figure 14 Another view of Fig.11, showing
the resemblance of the young Pierre-Louis
Vassé to his father.

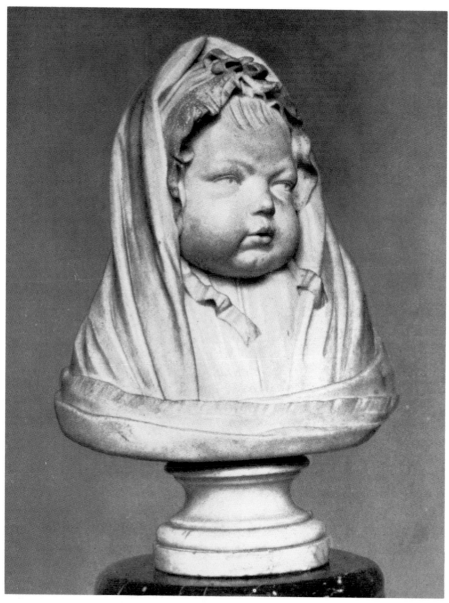

Figure 15 Louis-Claude Vassé, *Petit enfant au bonnet et au châle*, circa 1760; here proposed to be a portrait of Constance-Félicie Vassé, marble (App.6a). An old illustration of a unique subject.

Figure 16 *(opposite)* Louis-Claude Vassé, *Jeune fille aux frisettes*, 1770, marble (App.7a). The conventional style of this fine carving underlines the informality with which Vassé portrayed his own elder children (Figs.9,14).

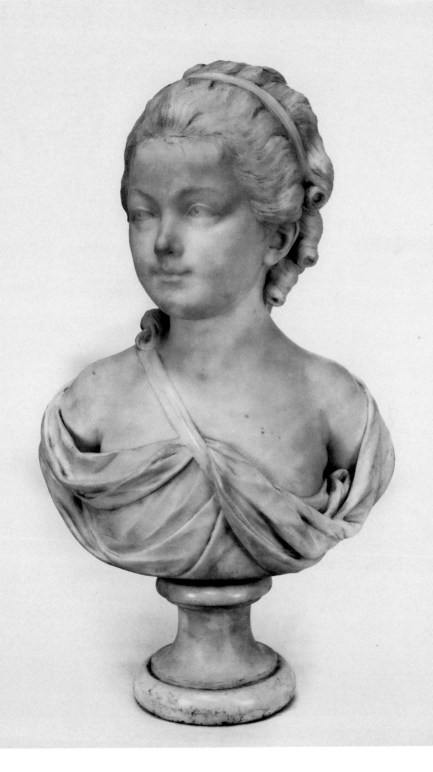

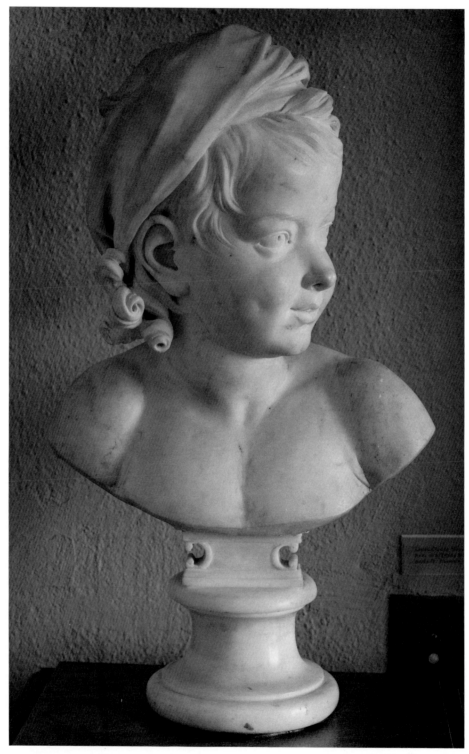

Figure 17 Louis-Claude Vassé, *Garçonnet au turban*, marble (App.3c). Collection:
The Huntington Art Gallery, San Marino, California. Proposed here to be the version
acquired by Thiroux d'Epersennes from the sculptor and paired with Saly's little girl (Fig.22).

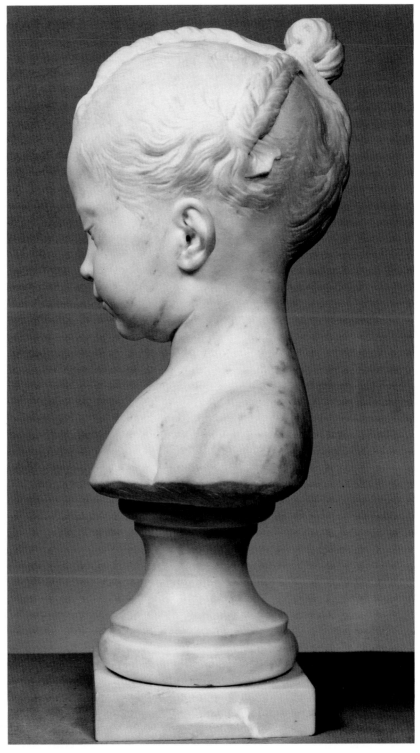

Figure 18 Jacques Saly, *Fillette*, circa 1745, marble, H. 49 cm, identified by Michael Levey (1972) as the daughter of Jean-François De Troy.
Collection: Victoria and Albert Museum, London.

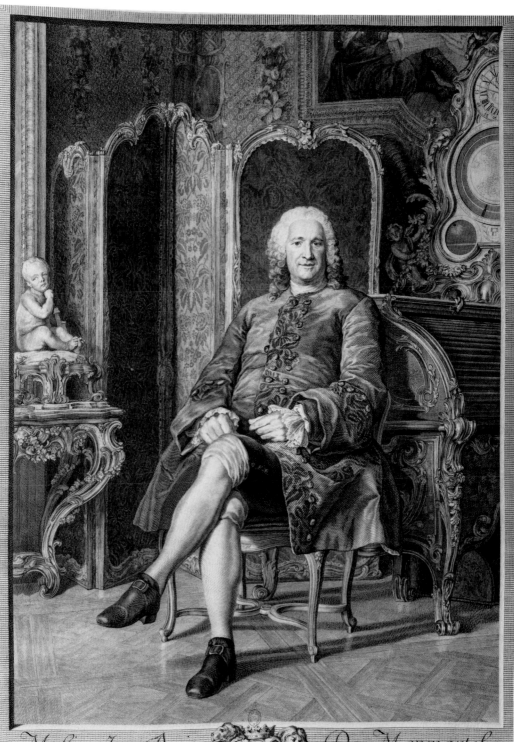

Messire Jean Paris De Monmartel

Cons.er d'État, Marquis de Brunoy, Comte de Sampigny, Baron de Dagonville,
Seigneur de Chateaumeillan, Chateauneuf et Autres Lieux.

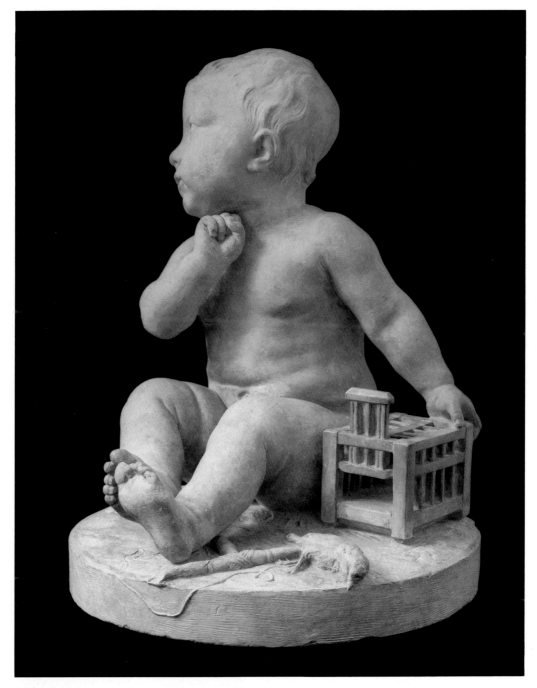

Figure 20 *(above)* Jean-Baptiste Pigalle, *Enfant à la cage avec oiseau mort*, circa 1749, stucco, H. 47 cm. An early project for the celebrated marble (seen in Fig.19), unique in having a strangled bird lying by the infant. Private collection.

Figure 19 *(opposite)* *'Messire Jean Paris De Montmartel...'*, the head after Quentin de la Tour, clothes and background by C.-N. Cochin Fils. Engraved by L. S. Cathelin. Cabinet des Estampes, B.N.

Figure 21 Falconet, after Boucher, *Le petit
pâtissier*, circa 1757, Sèvres white *biscuit*
statuette, H. 15 cm. Collection:
Musée National de Céramique, Sèvres.

Figure 23 *(opposite)* Jean-Baptiste II
Lemoyne, *Fillette, la tête couverte d'un fichu*,
1769, painted plaster, H. 27.7 cm.
Collection: Musée du Louvre, Paris.

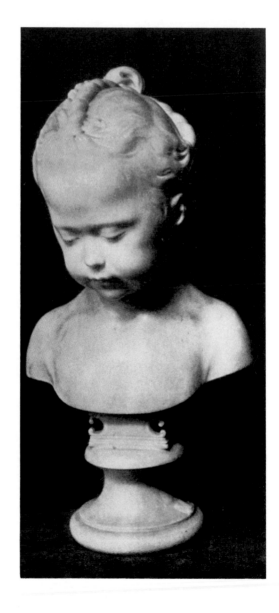

Figure 22 Jacques Saly, *Fillette*, circa 1742,
marble. An old illustration of the marble
proposed here to be the version acquired by
Thiroux d'Epersennes from the sculptor in
Rome and paired with the San Marino
Garçonnet (Fig.17).

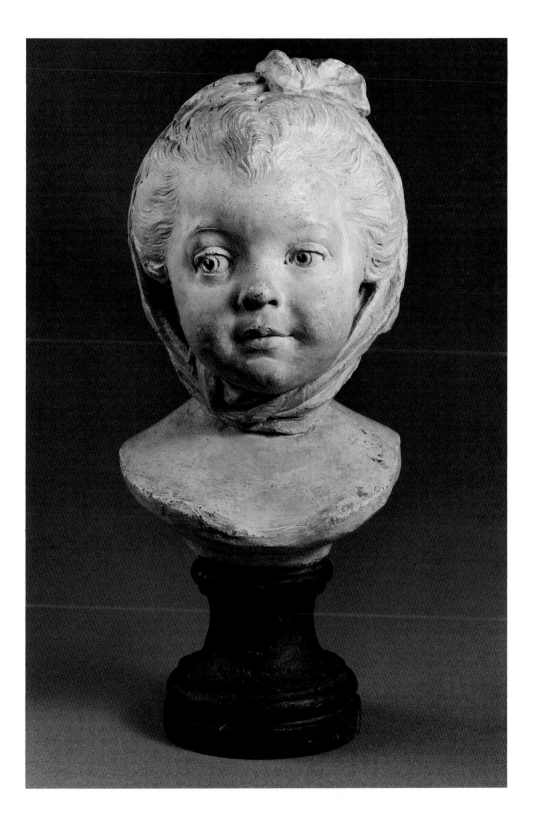

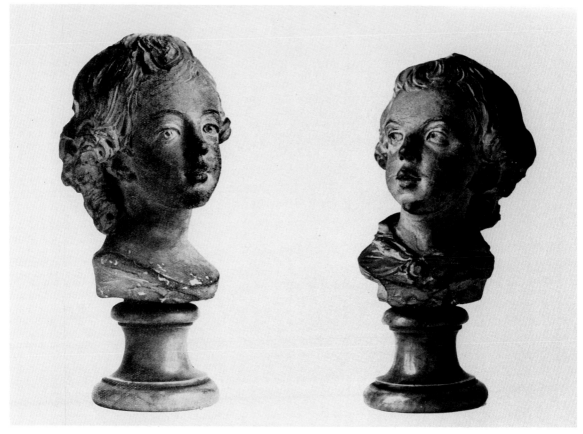

Figure 24 Jean-Baptiste II Lemoyne. Two terracotta studies of a small girl and boy,
H. 24 cm, proposed here to be of the sculptor's own children. Illustration from the
catalogue of the Octave Homberg auction sale, Paris, 1931.

Figure 25 *(opposite)* Jean-Baptiste Houdon, *Sabine Houdon*, aged 10 months, 1788,
marble, H. 44.5 cm, signed and dated. Collection: Metropolitan Museum of Art,
New York; bequest of Mary Stillman Harkness.

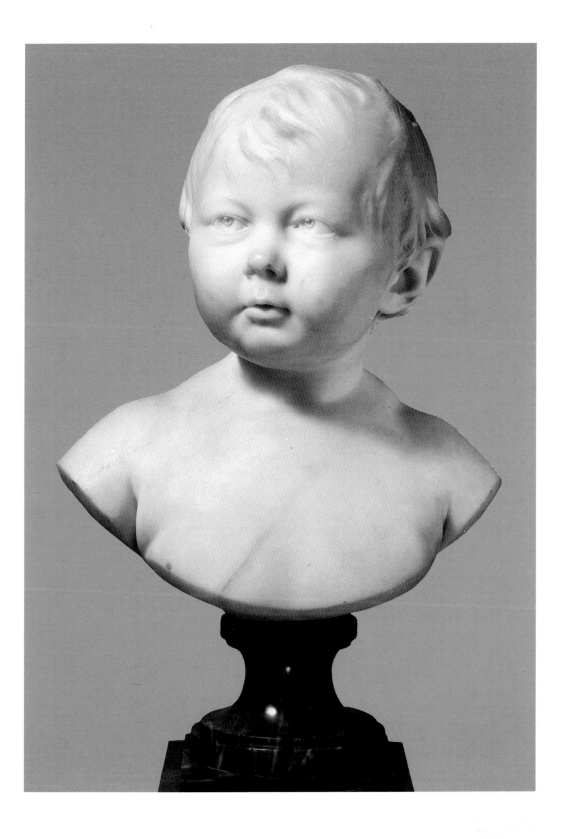

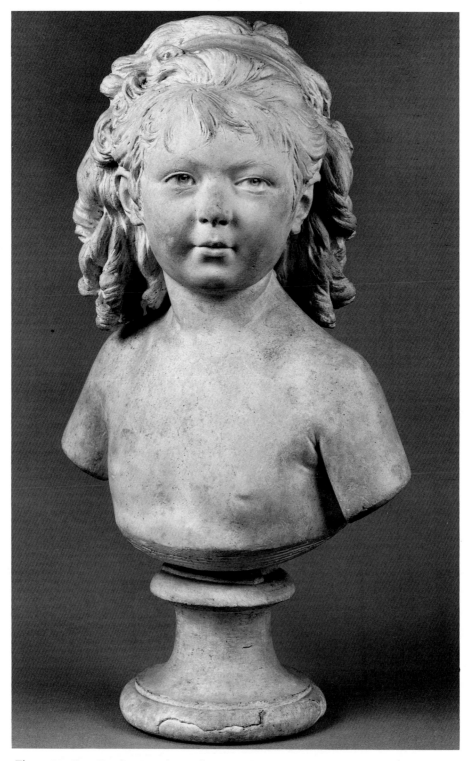

Figure 26 Jean-Baptiste Houdon, *Sabine Houdon*, aged 4 years, 1791, original plaster,
H. 52 cm. Collection: Musée du Louvre. Houdon's most popular child portrait, similar
in its timelessness to Vassé's marble of his daughter, Adelaide-Jeanne, in the 1760s (Fig.9).

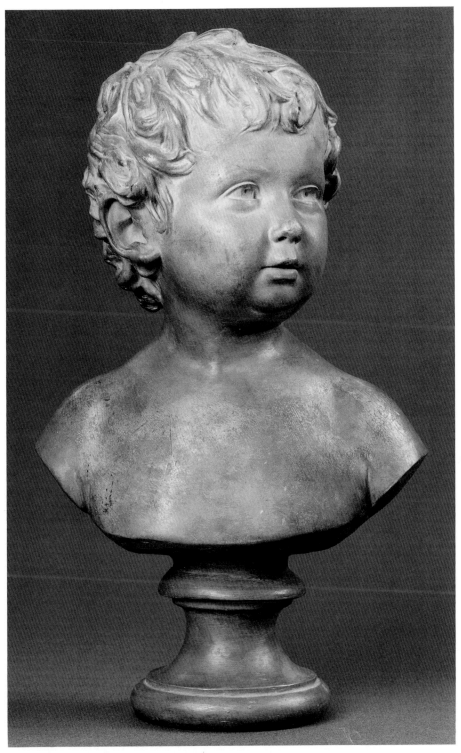

Figure 27 Jean-Baptiste Houdon, *Anne-Ange Houdon*, aged 3 years, circa 1791,
patinated plaster, H. 40 cm. Collection: Musée du Louvre.

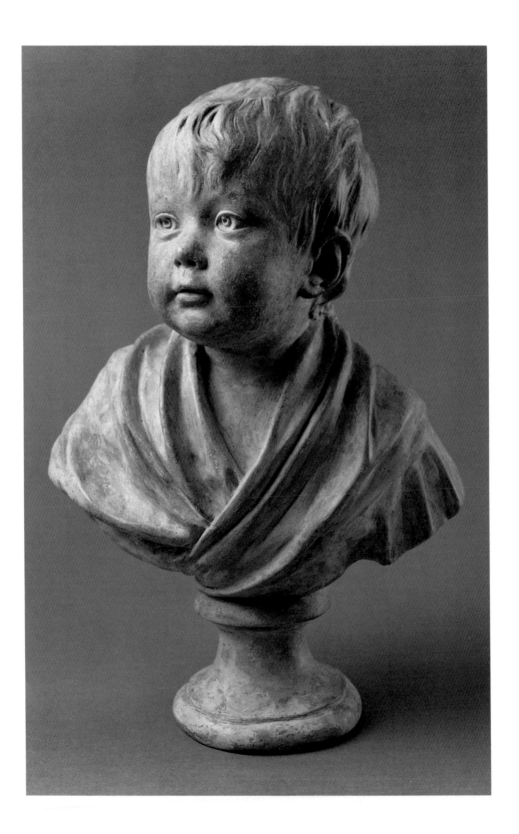

Figure 29 Title-page of the exceptional, single-lot catalogue of 1899. It offers one of Vassé's marble busts of his son, Louis, as '*A little girl*', an error which has dogged versions of this portrait to the present (ref.: App.3(b)).

Figure 28 *(opposite)* Jean-Baptiste Houdon, *Claudine Houdon*, aged 12 months, about 1791, patinated plaster, signed, H. 37 cm. Formerly, collection Florence J. Gould, Cannes. Private collection.

DÉSIGNATION

BUSTE, en marbre blanc, de fillette, grandeur nature, par *Vassé :* le visage est souriant, la gorge nue, la tête tournée vers l'épaule gauche ; une draperie cache les cheveux en partie. Signé : *Vassé fc, 1767*. Piédouche en marbre bleu-turquin. Époque Louis XV.

Haut., 0 m. 46 cent.

Vassé (Louis-Claude), sculpteur, élève de Puget et de Bouchardon, né à Paris en 1716, mort à Paris le 30 novembre 1772, 1er prix de Rome en 1739.

Figure 30 The catalogue description calls Louis-Claude Vassé a 'pupil of Puget', a less enduring misconception (ref.: p.25[9]).

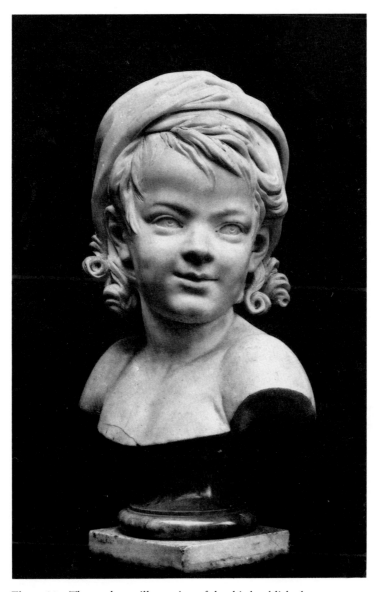

Figure 31 The catalogue illustration of the third published
marble of the *Garçonnet au turban*. It demonstrates the fine
carving which the sculptor maintained for this subject, the
first version of which was about 1758–59.

Appendix
I

An historical record of the presently-known child portraits
of Louis-Claude Vassé

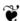

1 BUSTE DE L'ENFANT DE TROY
Material unknown. Circa 1742.
History: In a letter from Rome in 1742 to his former *maître*, Edmé
Bouchardon, Vassé mentioned that he had made a portrait, presumably a
bust, of the young son of Jean-François De Troy, then Director of the
French Academy there. This bust is otherwise undocumented.
Literature: Roserot, p.152.

2 (a) ENFANT A LA TETE DRAPEE D'UN FICHU
(Adelaide-Jeanne Vassé, aged about 2 years.)
Marble; on a turned, white marble socle, (Fig.2).
Signed and dated: *'Vassé f. 1757'*. Total height: 44 cm.
Collection: Réunion des Musées Nationaux, France.
History: 'Cabinet de M. Aranc de Presle', sold Paris – 16/24 April 1792,
lot 190 (height *'18 pouces'* or 48.6 cm); 'Cabinet du citoyen Robit', sold
Paris – 11 May 1801, lot 212; – in these two sales, catalogued
individually but described as pendant to '3(e)'; Colln. Jacques Doucet,
sold Paris – 6 June 1912, lot 122, illd., for Fr. 75,100; – according to Réau
(p.53), purchased by Joseph E. Widener, Philadelphia, but this is
erroneous; acquired by the Musées Nationaux in 1982.

Literature: Paul Vitry, 1903, p.11; Paul Vitry, entry for lot 122, Doucet sale catalogue (see above); *La Revue du Louvre*, 3–1982, XXXI^e année, p.219 (as an acquisition by the Musée des Beaux-Arts, Caen), illd.

(b) Marble; on a turned, coloured marble socle mounted on a square base. Apparently unsigned. Height unrecorded.
History: Known only from its illustration in Alexander Watt, 'Notes from Paris', *Apollo*, vol.27, April 1938, pp.207–8, 'recently discovered in a French private collection, where it had remained unrecognized for over a century'; André Seligmann, Paris.

(c) Marble; on a turned, grey marble socle mounted on a square white marble base. Unsigned. Height: 45 cm, (Fig.7). Inscribed in ink on the socle: '*D W 841*'.
History: Colln. David-Weill, Paris; included in an exhibition: 'French XVIIIth Sculpture formerly of the David-Weill Collection', Wildenstein & Co., New York, April 1940, cat. no.18; Jacques Helft, New York; 'Collection d'un Amateur Etranger', sold Sotheby's Monaco – 14 June 1982, lot 315, as '*Buste de jeune garçon*', illd., for Fr.55,000.
Literature: Charles Morice, 'La Collection David-Weill', *L'Art et les Artistes*, September 1907, p.235.
Note: Despite a distinguished provenance, the dryness and shallow detail of this bust, when compared with the virtuosity displayed in the carving of '2(a)', suggests that it is a workshop version, if not later.

(d) Terracotta model; on a shaped, square pink and grey marble base. Unsigned. Total height: 42 cm. Height of base: 11.3 cm, (Fig.6).
Collection: Private.
History: Sold Sotheby's Monaco – 27 May 1980, lot 1164, illd., for Fr.16,000.
Literature: Apollo, Nov. 1981, p.9, illd.; *NACF Annual Report*, London, 1982, p.vi, illd.

(e) Cast (?) terracotta; on a turned, brecciated marble socle. Unsigned. Total height: '16 inches', 40.5 cm, (Fig.8).
History: Colln. David-Weill, Paris; included in an exhibition 'French

XVIIIth Century Sculpture formerly of the David-Weill Collection', Wildenstein & Co., New York, April 1940, cat. no. 17; Jacques Helft, New York; Colln. Baron Cassel van Doorn, sold Parke Bernet Galleries, New York – 6 Dec. 1958, lot 116, illd., for $9,000; Colln. Mrs. Thorneycroft Ryle, N.Y., sold Parke Bernet Galleries – 17 Jan. 1964, lot 309, illd., for $8,000.
Literature: Apollo, no.79, March 1964, p.255, illd. (sale report); *Connoisseur*, no.156, July 1964, p.213, illd. (sale report).

3 (a) GARCONNET AU TURBAN
(Pierre-Louis Vassé, aged about 4 years.)
Marble; on a turned, white marble socle. Signed and dated 1759. Total height: 48 cm, (Fig.11).
Collection: Musée des Beaux-Arts, Lyon.
History: Salon of 1759; Colln. M. et Mme Filiter, bequeathed to the Musée de Lyon in 1926.
Literature: Réau, p.53 and fig.12, as *'Buste de fillette'*; Lyon, p.41, illd., as *'Buste de fillette'*.

(b) Marble; on a turned, *bleu-turquin* marble socle, mounted on a square, white marble base. Signed and dated: *'Vassé fe. 1767'*. Total height: 46 cm, (Fig.31).
History: Colln. Talleyrand, sold (anonymously) in a single-lot sale, Paris – 6 May 1899, as *'Buste de fillette'*, illd., for Fr.20,700; Colln. Paul Desmarais until July 1930, at least; not traced since.
Literature: Réau, p.54.

(c) Marble; on a turned, white marble socle supporting a section waisted with 'C' scrolls. Unsigned. Total height: 48 cm, (Fig.17).
Collection: The Huntington Art Gallery, San Marino, California.
History: Colln. Alfred Sussmann, sold Paris – 18, 19 May 1922, lot 69, as *'Buste de Fillette'*, illd., for Fr.37,000; Colln. Paul Dutasta 'Ancien Ambassadeur', sold Paris – 3, 4 June 1926, lot 71, as *'Buste de Fillette'*, illd.; Colln. Mrs Mildred Browning Green, bequeathed to The Huntington Art Gallery, San Marino, Cal., 1978.
Literature: P. Dirion, 'Les Grandes Ventes de la Saison – Collection de

M. Sussman', *La Renaissance de l'Art français*, no.5, May 1922, p.354, illd., as *'Buste de fillette'*; Réau, fig.13, as *'Buste de fillette'*, although cited in his text (p.53) as a *'buste de jeune garçon'*; Wark, p.102, illd.

Note: As proposed in the text, this is probably the same bust as '3(d)'.

(d) Marble. Height unknown.

History: Cited in Babelon, p.109, as in the collection of Thiroux d'Epersennes. The collection included a marble version of Jacques Saly's pouting little girl, as well as this *Garconnet* by Vassé '... formant la paire avec la tête de jeune fille de Saly. On sait que Vassé s'était fait une specialité de ces bustes de jeune garçons ...' (! -Author) '... L'oeuvre figure dans le testament de 1764 et l'inventaire de 1767 pour la somme de 300 livres. Elle fut léguée à Mme d'Arconville, mais nous perdons ensuite sa trace.'

Note: As proposed in the text, this marble is probably an earlier appearance of '3(c)'.

(e) Marble. Unsigned. Height: '18 pouces', 48.6 cm.

History: 'Cabinet de M. Aranc de Presle', sold Paris – 16/24 April 1792, lot 191; 'Cabinet du citoyen Robit', sold Paris – 11 May 1801, lot 213. In both instances, catalogued individually but described as pendant to '2(a)'.

4 (a) BUSTE DE FILLETTE A L'EPAULE DRAPEE

(Adelaide-Jeanne Vassé, aged 4–5 years.) Modelled circa 1759.
Marble; on a turned grey marble socle with square base. Unsigned.
Total height: '18½ inches' 47 cm, (Fig.10).

History: Colln. Princesse Faucigny-Lucinge, Paris; sold anonymously, Parke-Bernet Galleries, New York – 26 March 1970, lot 159, illd., for $550.

(b) Marble; on a turned, coloured marble socle mounted on a shaped, square, white marble base. Unsigned. Inscribed 'P M 393' in ink. Total height: 46 cm.

History: 'Collection d'un Amateur Etranger' sold Sotheby's Monaco – 14 June 1982, unattributed, lot 319, illd., for Fr.40,000.

Note: The lacklustre quality of this bust is similar to that of '2(c)', suggesting that it is by the same workshop (or later) hand.

5 (a) JEUNE FILLE, LES CHEVEUX RELEVES PAR UN RUBAN
(Adelaide-Jeanne Vassé, aged 8–8½ years.)
Marble; signed and dated 1763. Height unrecorded.
History: ? Salon of 1765; Colln. Paul Lebaudy, exhibited 'Marie-Antoinette et son temps', Galerie Sedelmeyer, Paris 1894, no.235: '*Petit buste de jeune fille marbre, portant les cheveux relevés et maintenus par un ruban. Signé et daté:* VASSE 1763', not illd.
Literature: Réau, p.53; Seznec and Adhemar, vol.I, p.189, (relation to the *modèle* of the Salon of 1763); vol.II, p.47: 'personne ne parle de la *Tête d'enfant* dont le modèle été exposé au Salon de 1763 …'.

(b) Marble; on a turned white marble socle. Signed.
Total height: 47 cm, (Fig.9).
Collection: The Huntington Art Gallery, San Marino, California.
History: Colln. Joseph E. Widener, Philadelphia, by 1926; Colln. Mrs Mildred Browning Green, bequeathed to The Huntington Art Gallery in 1978.
Literature: L. Réau, *L'Art Français aux Etats-Unis*, Paris 1926, pp.158–159 (Widener Collection); Elizabeth Pomeroy, *The Huntington*, London 1983, p.96, illd.; Wark, p.102, illd.

(c) Plaster or terracotta. Height unknown.
History: Shown in the Salon of 1763. No further trace.
Literature: *Livret*, Salon of 1763, no.169; Seznec and Adhemar, vol.I, p.189: 'Nous identifierons volontiers la *Tête d'enfant en plâtre* avec la Jeune fille qui appartient à P.Lebaudy …'. (However, the sculpture is not described as a plaster in the *livret* and their assertion, evidently based on the preceding work being '*en plâtre*', is logical but without regard for the fallibility of the old Salon catalogues.)

6 PETIT ENFANT AU BONNET ET AU CHALE
(? Constance-Félicie-Victoire Vassé, born 20 June 1760)
Marble, on a turned, white marble socle, mounted on a later octagonal, black marble base. Not signed. Height unrecorded but certainly life-size. (Fig.15).
History: Colln. Mme Louis Stern, Paris; Colln. M. Jean Stern, Paris.

Literature: Carle Dreyfus, 'La Collection de Madame Louis Stern', *Les Arts*, no.119, Nov. 1911, pp.2–14, illd., described as: '… cet enfant sérieux et joufflu, dont la tête est coiffée d'un bonnet de dentelle surmonté d'un capuchon …'; Réau, p.54 and fig.14, as *'Buste de fillette'.*

7 (a) BUSTE DE JEUNE FILLE AUX FRISETTES
Marble, on a turned white marble socle. Signed and dated:
'Ludovicus Vassé, fecit 1770'. Total height: 52 cm, (Fig.16).
History: Colln. George Blumenthal, Paris; Colln. Baroness von Wrangell, sold Sotheby's, London – 11 December 1970, lot 24, illd., for Ł3,400.; Anonymous sale, Ader-Picard-Tajan, Paris – 15 April 1989, lot 3, illd., for Fr.780,000.

(b) Plaster, on a turned, green marble socle. Unsigned. Total height: 53 cm. (Showing some variations to '7(a)' in the hair, particularly the flowers embellishing her head-band.)
History: Anonymous sale, Laurin-Guilloux-Buffetaud-Tailleur, Paris – 8 December 1989, lot 98, illd., for Fr.135,000.

8 TETE DE PETIT GARCON
Plaster, on a turned marble socle. Signed and dated: *'L. Vassé F. 1771'.*
Total height: 34 cm.
History: Anonymous sale, Ader-Picard-Jozon, Paris – 28 November 1970, lot 56, illd., for Fr.6,200.

UNASSIGNABLE

9 (a) In the *inventaire après décès* of Vassé, an unspecified number of heads of infants are listed in the *atelier* (Coural, pp.207,208). These also appear in the sale of his estate in 1773, the sculpture section of which is reproduced here as Appendix II: 'p.9', lot 42: *'Plusieurs têtes d'enfans & Autres, en marbre'* and 'p.10', lot 52: *'Divers têtes d'enfans, idem'* (i.e., in plaster) including, presumably, studies of heads other than portraits, intended for larger compositions.

(b) 'FILLETTE'

Terracotta; unsigned. Height: '15 3/4 inches', 40 cm.

History: Colln. David-Weill, Paris; included in an exhibition: 'French XVIIIth Sculpture formerly in the David-Weill Collection', Wildenstein & Co., New York, April 1940, cat. no.19, not illd.

Note: Messrs. Wildenstein are unable to provide any further information on this third Vassé bust from the collection as there was no photographic record.

Appendix
II

Sculptures included in the catalogue of the auction sale of
Vassé's *atelier* and *cabinet* after his death.

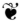

In 1978, Jean Coural published those sections of Louis-Claude Vassé's
inventaire après décès, dated 17 December 1772, pertaining to his drawings,
engravings, books on architecture, sculpture and paintings (see Bibliography).
The sale of the sculpture, paintings and engravings from his studio and *cabinet*,
by auction, took place in January 1773 and, the catalogue of that sale being
scarce (recently, the only copy in Paris accessible for consultation was that in
the Bibliothèque Mazarine), it has been considered useful to reproduce on the
following pages a copy of its section containing the sculptures and models
in marble, terracotta and plaster which were offered for sale, including the
handwritten notes on the prices achieved (N.B. 1 *livre* equals 20 *sous*).

The catalogue 'page 9' lists *'several heads of infants and others'* in marble
(lot 42), which brought the high price of 310 *livres* 14 *sous*. Its 'page 10' lists
'various heads of infants in plaster' (lot 52) which brought a low price,
suggesting that these were few in number. Given the limited production of
Louis-Claude Vassé's child portraits, indicated by Appendix I, it is unlikely that
many of these infant heads in the two lots belonged in that category and less
likely that the portraits of the Vassé children themselves would have been
offered in such miscellaneous groups.

CATALOGUE
DES SCULPTURES, PEINTURES ET GRAVURES
De l'Atelier & Cabinet de feu M. Vassé,
Sculpteur du Roi, & Dessinateur de son Académie
des Inscriptions, Membre des Académies de
Florence & autres.
Par Fr. BASAN
Dont la Vente se fera, aux Grands Augustins,
le Mercredi 20 janvier 1773, & jours suivans de relevée,
en la maniere accoutumée, an plus offrant &
dernier encherisseur.

chez Basan, rue et Hôtel Serpente
M.DCCLXXIII

(page 7) SCULPTURES

960... 13 Un groupe, en marbre blanc & bien conservé, de la
composition & ébauché par Ant. Vassé père, & terminé par
son fils, représentant Venus et l'Amour assis, de deux
pieds de proportion.

non ⎰ 14 Une Figure de femme endormie, dont le corps est nud & bien
Vendu ⎱ développé, d'un pied & demi de longeur, executée en marbre
 par L. Cl. Vassé fils.
 ⎰ 15 Une Nymphe de même grandeur, se mirant dans l'eau, par
 ⎱ le même.

6...13 16 Un vaze de terre, dont la garniture est modelée en cire,
par le même.

145...4 17 Plusieurs vases en yvoire, plâtre, &c.

15..." 18 Une petite Figure de femme, en plâtre, assise dessous une
cage de verre.

12..." 19 Les bas-reliefs, en terre cuite, de la Fontaine de
Grenelle, sujets d'enfans représentant les Saisons.

12..." 20 Le modèle, en petit & en cire, du groupe principal de la
même Fontaine, par Bouchardon.

(page 8)

60... 21 Les trois figures principales de ladite Fontaine,
en plâtre.

(page 8, suite)

110... 22 Un modèle, en terre cuite, par Bouchardon, représentant
 un sujet propre à décorer un grand bassin, orné de
 Tritons & de differens animaux aquatiques.

6...19 23 Le bas relief, en terre cuite, du Martyre de
 St. Etienne, executé en grand, par L. Cl. Vassé.

36... " { 24 Un autre, en plâtre, de même grandeur que celui qui à été
 executé pour Auxerre.

{ 25 Le Tombeau de N.S. en plâtre, de même grandeur que celui
 qui doit être executé en marbre, pour le tabernacle de
 St. Germain-l'Auxerrois.

12... ˚ 26 Le Tombeau, en plâtre, de la Princesse de Galitzine.

3...10 27 La figure, en plâtre, de St. Etienne.

16... " 28 Le modèle, en terre cuite, pour le Tombeau du coeur de
 la Reine, qui doit être placé à Nancy.

12... " 29 Une Figure, en plâtre, de grandeur naturelle,
 représentant la Douleur.

40...19 30 La Figure, en terre cuite, du Milon, d'après le Pujet.

194... " 31 L'Amour de Bouchardon, en plâtre de grandeur naturelle,
168... " & plusieurs autres grandes figures.

48...2 32 Deux petites terres cuites, d'après l'antique,
 représentant un Sanglier & un Cerf.

(page 9)

76...19 33 Les figures de Minerve & de Diane, propres à orner un
102...1 vestibule ou un jardin, de 6 à 7 pieds de haut, en
 plâtre, par Vassé.

9... " Les Muses du fronton de l'Opéra, aussi en plâtre, idem.

79...19 34 Une figure de femme sortant du bain, de grandeur naturelle,
 par le même.

72... " 35 Une, idem, de Nayade endormie sur une urne, & une autre se
 mirent dans l'eau.

30... " 36 Une figure de Hermaphrodite, en plâtre, de grandeur
 naturelle.

397...15 37 Plusieurs petites figures en pieds, dont l'Amour &
 l'Amitie, Hercule, &c qui seront divisées. en 22 loti

114... " 38 Plusieurs plâtres de la figure équestre de Louis XV, en
 en petit.

56...19 39 Le figure de Milon du Pujet, colosse & estampée sur le
 marbre dont il existe aucun autre plâtre.

12... " 40 Deux modèles, en plâtre & bois, frontons de bâtimens.

(page 9, suite)

6... " 41 Un bas relief, en marbre blanc, représentant le Char
 de la Paix.

76... " Un très joli bas relief, en pierre de jade
 verdâtre, de trois pouc. sur 2 de haut environ,
 représentant un Guerrier dans un char attelé de
 quatre coursiers, précédé de la Rénommée, & couronné
 par la Victoire.

310...14 42 Plusieurs têtes d'enfans & autres, en marbre.

 43 Plusieurs tables de marbre blanc, polies & non polies,
 de diverse grandeurs. *en 3 articles* 739...2
 en 15 loti

(page 10)

319..15 44 Divers moyens et petits morceaux de marbre blanc, de
 differentes formes & grosseurs. *en 11 loti*

5074...14 Plusieurs blocs, aussi de marbre blanc, de differentes
 grandeurs depuis 3 pieds jusqu'à 6 de hauteur. *sur 14 loti*

500... " Lesquels seront divisés & dont on annoncera les
3 blocs randeurs en les vendant.

13...5 45 Plusieurs Consoles, en marbre, bois et plâtre.

40... " 46 Plusieurs modèles de Tombeaux, en terre cuite, plâtre
 & cire. *en 6 loti*

5... " 47 Le modèle d'une des guérites de la Place de Louis XV.

138...17 48 Plusieurs bas reliefs, représentant differens sujets,
 les quels seront divisés. *en 18 loti*

405...17 49 Plusieurs têtes de femmes, en terre cuite & plâtre. *en 25 loti*

159... " 50 Plusieurs têtes antiques et modernes, en plâtre. *en 20 loti*

91... 12 51 Divers bras et pieds de grosseur naturelle, aussi
 en plâtre. *en 19 loti*

26... " 52 Divers têtes d'enfans, <u>idem</u>.

92...19 53 Quantité de pieds & mains, & autres bosses.

36... " 54 Divers groupes de figures en cire & en plâtre.

120...10 55 Divers têtes & sujets en médaillons, en plomb & plâtre. *en 20 loti*

14... 1 56 Le portrait en médaillon d'argent d'Anne de Montmorency.

 (57 - 63 Pierres gravées antique, objets en fer, selles,
 chevalets de bois, six grandes boëttes rempli d'outils
 necéssaire au talent de la sculpture en marbre, &c.)

50...10 64 Divers creux de différentes têtes & figures dont M. Vassé
 etoit l'auteur.

Bibliography

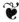

BABELON, Jean-Pierre. 'Les Falconet de la Collection Thiroux d'Epersennes', *B.S.H.A.F., année 1964*, Paris 1965, pp.101–111.

BACHAUMONT, L. Petit de. *Mémoires secrets … (1762–1785)*, London, 1784–1789, vol.VI (1772).

BALLOT, Marie-Juliette. *Le Décor Intérieur au XVIIIe Siècle à Paris et dans la région Parisienne*, Paris 1930.

BEAULIEU, Michèle. (Entry for Vassé) in: Paris, Hôtel de la Monnaie, *Louis XV – un moment de perfection de l'Art français*, exn. cat., Paris 1974.

BENOIST, Luc. *La Sculpture Française*, Paris 1963.

BRESC-BAUTIER, Geneviève. *Sculpture française XVIIIe*, (Ecole du Louvre, Notices d'Histoire de l'Art, no.3), Paris 1980.

COCHIN, Ch.-N. *Mémoires inédits sur le Comte de Caylus, Bouchardon, les Slodtz*, ed. Charles Henry, (Soc. de l'Histoire de l'Art Français) Paris 1880.

Correspondance des directeurs de l'Académie de France à Rome avec les surintendants des Bâtiments, 18 vols., publiée par A. de Montaiglon et J.-J. Guiffrey, Paris 1857–1908.

COURAL, Jean. 'Note sur le tombeau de Paul-Esprit Feydeau de Brou par Louis-Claude Vassé', *La Revue de l'Art*, no.40/41, 1978, p.203 et seq.

DILKE, Lady Emilia. *French Architects and Sculptors of the XVIIIth Century*, London 1900.

DRAPER, James David. 'French Terracottas', *The Metropolitan Museum of Art Bulletin*, New York, Winter 1991/1992.

DUBOIS-CORNEAU, Robert. *Pâris de Montmartel (Jean) 1690–1766 – Origine et vie des frères Pâris*, Paris 1917.

FAŸ-HALLE, Antoinette. 'The Influence of Boucher's Art on the Production of the Vincennes-Sèvres Porcelain Manufactory' in *François Boucher*, exn. cat., New York, The Metropolitan Museum of Art, Feb.–May 1986, p.345 et seq.

GABORIT, Jean-Réné. 'Louis-Claude Vassé', in: Paris, Hôtel de la Monnaie, *Diderot et l'Art de Boucher à David*, 1984, exn. cat., pp.477–481.

——— *Jean-Baptiste Pigalle, 1714–1785 Sculpture du musée du Louvre*, Paris 1985.

——— 'L'*Amour* de Louis-Claude Vassé, au Louvre', *Revue du Louvre*, 1–1987, pp.39–42.

——— *Nouvelles Acquisitions du Dépt des Sculptures, 1984–1987*, Musée du Louvre, Paris 1988, pp.72–74.

——— 'Le goût de Madame Du Barry pour la sculpture' in: *Madame Du Barry – De Versailles à Louveciennes*, Paris 1992, p.120 et seq.

GINOUX, Charles. 'Trois sculpteurs du nom de Vassé', *Réunion des Sociétés des Beaux-Arts*, Paris 1888, p.32 et seq.

GRIMM, Baron F.M. von and DIDEROT, Denis. *Correspondance littéraire, philosophique et critique de Grimm et de Diderot (1753–1790)*, new edition, vol.IV (1764–1765), Paris 1829 and vol.VIII (1772–1776), 1830.

GUIFFREY, J.-J. 'Les sculpteurs Antoine Vassé et Louis-Claude Vassé – Documents communiqués par M. J.-J. G. …', pp.149–157; also 'Brevets de pensionnaires à l'Académie, de Rome … Extraits réunis par M. J.-J. G. …', pp.350–392; both in *Nouvelles Archives de l'Art français*, 2nd series, vol.1, Paris 1879, pp.149–157.

JOUIN, Henry. *Jacques Saly*, Macon 1896.

LAMI, Stanislas. *Dictionnaire des Sculpteurs de l'Ecole Française au Dix-huitième Siècle*, vol.2, Paris 1911, pp.370–380.

LAPAUZE, Henry. *Histoire de l'Académie de France à Rome*, vol.I (1666–1801), Paris 1924.

LEVEY, Michael. 'A New Identity for Saly's "Bust of a Young Girl"', *Burlington*, vol.CVII, Jan. 1965.

——— *Painting and Sculpture in France 1700–1789*, Pelican History of Art, New Haven & London 1992.

LEVEY, Michael and KALNEIN, Wend, Graf. *Art and Architecture of the Eighteenth Century in France*, Pelican History of Art, London 1972.

LYON. *Le Musée des Beaux-Arts de Lyon* (Series: 'Musées et Monuments de France'), ed. Philippe Durey, Paris 1988.

MARIETTE, Pierre-Jean. *Abécédario*, published by P. de Chennevières and A. de Montaiglon, *Archives de l'Art français*, XII, Paris 1859–60.

MONTAIGLON, Anatole de. 'L.-C. Vassé' in *Archives de l'art français*, 8th year, Paris, 15 November 1858, pp.269–272.

PIERRE, J. *Histoire singulière et véridique de CINQ BUSTES en marbre offerts à la ville de Troyes par Grosley et executés par le sculpteur Louis-Claude Vassé*, Paris 1902.

RAGGIO, Olga. *The Fire and the Talent – A Presentation of French Terracottas*, Metropolitan Museum of Art, New York, 1976.

REAU, Louis. *Etienne-Maurice Falconet*, Paris 1922.

—————— *L'Expansion de l'Art français – Le monde slave et l'orient*, Paris 1924.

—————— *Une dynastie de sculpteurs au XVIIIème siècle: les Lemoyne*, Paris 1927.

—————— 'Un sculpteur oublié du XVIIIe siècle – Louis-Claude Vassé', *Gazette des Beaux-Arts*, 1930 (2), p.53 et seq.

—————— *Jean-Baptiste Pigalle*, Paris 1950.

—————— *Houdon – sa vie et son oeuvre*, Paris 1964.

ROSEROT, Alphonse. *Edmé Bouchardon* (Les grands sculpteurs français du XVIIIe siècle), Paris 1910.

SEZNEC, Jean and ADHEMAR, Jean. *Diderot Salons*, 4 vols., Oxford 1957–1967.

SOUCHAL, François. *Les Slotdz*, Paris 1967.

—————— 'The Nymph of Dampierre', *Apollo*, no.189, November 1977, pp.406–410.

—————— *French Sculptors of the 17th and 18th centuries – The reign of Louis XIV*, vol.III, Oxford 1987, pp.402–442.

STEIN, Henri. *Le sculpteur Louis-Claude Vassé – Documents inédits*, Paris 1886.

TARBE, Prosper. *La vie et les oeuvres de Jean-Baptiste Pigalle*, Paris 1859.

WEINSHENKER, Ann Betty. *Falconet: His writings and his friend Diderot*, Geneva 1966.

VIATTE, Françoise. Biographical notes on Pierre-Jean Mariette in: 'Le Cabinet d'un grand Amateur', exhibition cat., Musée du Louvre, Paris 1967.

VITRY, Paul. 'La Collection de M. Jacques Doucet', *Les Arts*, no.21, September 1903, pp.2–19.

—————— 'Houdon, portraitiste de sa femme et de ses enfants', *La Revue de l'Art ancien et moderne*, vol.XIX, Jan.–June 1906.

WARK, Robert R., ed. *A Handbook*, The Huntington Art Collections, San Marino, California 1987.

Index